101

MORE MIXED MEDIA
TECHNIQUES

Walter Foster

Cherril Doty

Heather Greenwood

Monica Moody

Marsh Scott

Quarto is the authority on a wide range of topics.
Quarto educates, entertains, and enriches the lives of our readers—
enthusiasts and lovers of hands-on living.
www.quartoknows.com

Project Editor: Dana Bottenfield
Page Layout: Elizabeth T. Gilbert

6 Orchard Road, Suite 100
Lake Forest, CA 92630
quartoknows.com
Visit our blogs at @quartoknows.com

Printed in China
1 3 5 7 9 10 8 6 4 2

101

MORE MIXED MEDIA
TECHNIQUES

Table of Contents

Introduction

"Not all those who wander are lost." – J.R.R. Tolkien

This describes how I feel about art. As an artist, I am not bound to one path or destination. It's more about the journey—what I discover, how I explore, and who I become along the way.

A beautiful work of art may be the desired destination, but it is the process itself I adore most. I love to WANDER.

W – Wonder

A – Assemble

N – Nurture

D – Discover

E – Experiment

R – Refine or Relax

Wonder: I'm inspired by the wonder of experiences, such as music, nature, and emotion. Sometimes my "wonder" is simpler: "I wonder what a purple owl would look like?"

Assemble: I assemble tools and supplies, or at least what I suspect I'll need. The list almost always changes.

Nurture: I nurture my inner child by playing. Occasionally, I have to remind myself to do this. Just let go!

Discover: Through playing, I discover a new technique or the direction I want to go with a specific piece.

Experiment: I feel like a mad scientist in a laboratory when creating because I experiment—always. I may learn how not to do something, or I may devise a unique procedure or style.

Refine or Relax: I have to make a decision, which is often the most difficult part for me. Does a piece need more layers or detail? If so, refine. Does it work as is? If so, relax! Don't overwork it.

Creating with mixed media allows me to enjoy and constantly learn from my journey. There are no rules, and the possibilities are limitless. I am free to wander, and so are you!

—Monica Moody

How to Use This Book

In this book you'll find instructions and inspiration for 101 mixed-media techniques. You can use these techniques individually or combine as many as you wish to create mixed media art.

Each section includes a list of the materials you'll need for the techniques in that section. Review the techniques before you get started to ensure you have the proper materials. But remember: Mixed media is a flexible art form. If you don't have an item listed, use your imagination and see if you can find something else to use!

There are 17 sections of techniques in the book. You can mix and match from any of these sections to create unique works of art:

Borders & Edges · **Embossing & Casting** · **Drips, Drops & Sprays** · **Aging & Antiquing** · **Pens, Pencils & Pastels** · **Yarn & String**

Fabrics & Fibers · **Using Metals** · **Resists & Masking** · **Alcohol Inks** · **Watercolor Monotypes** · **Pyrography**

Washi Tape · **Alternative Surfaces** · **Spray Ink** · **Ephemera** · **Gelatos®**

Borders & Edges

with Cherril Doty & Marsh Scott

Artists often ignore the edges of their works; however, borders and edges can enhance certain themes or create a unique frame. Adding borders or otherwise finishing off the edges of a work also creates visual interest in a piece.

Materials

- Substrates (with or without completed artwork)
- Ruler
- Variety of edging scissors (pinking shears, fabric shears, edge-cutters)
- Rotary cutter or paper trimmer
- Watercolor paper
- Container of water
- 1" brush
- Old cookie sheet or baking pan
- Lighter
- Acrylic paints
- Acrylic medium
- Acrylic gel
- Painter's tape
- Assorted printed papers
- Deli paper
- Sea sponge
- Used dryer sheets or dry baby wipes
- Cosmetic sponge
- Blunt, short-bristled brush
- Rub 'n Buff® or gilders paste

Cut, Torn & Colored Edges

Cut and Torn Edges

Tearing (below): This can be done with wet or dry paper. Dry tearing creates an even edge, whereas wet tearing creates a deckled effect. For wet tearing, watercolor paper works best.

Cutting (right): Hard edges are created using a mat knife, rotary cutter, or paper trimmer. When cutting, cut along the outside of the ruler so the artwork will not be damaged. Thick, textural pieces may take several cuts.

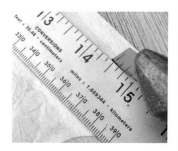

Step One Moisten the front and back edges of the paper. Allow the paper to absorb the water.

Step Two Place a hard-edge ruler on the inside of paper, and tear paper away from the ruler.

Above
Left: Cut edge
Center: Dry tear
Right: Wet tear

Colored Edges

Colored accents can be added to torn or sharp edges using several mediums.

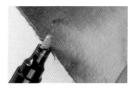

Lightly apply paint to edges using a blunt, short-bristled brush (top left) or a cosmetic sponge (top right).

Lightly apply Rub 'n Buff® or gilders paste to edges using your fingertips or a soft, lint-free rag.

Use pens and markers to highlight edges. Use the side of the nib or a brush-tip pen for best results.

Burned Edges & Sharp Borders

Burned-Edge Border

A burned edge lends an irregular darkening effect to paper. This method works best with torn edges.

Light the edge of a torn-edge sheet of watercolor paper with a lighter, one inch at a time, making sure the flame is extinguished before moving on. Continue around the paper until the burned edge is complete.

Tip
For your safety, work over a cookie sheet, baking pan, or on a concrete or metal surface outdoors in a wind-free environment. Keep a container of water nearby.

Sharp-Edge Border

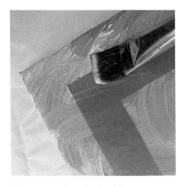

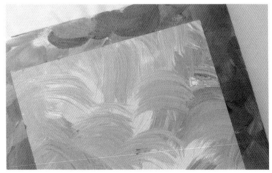

Measure and mark a border, using a straight edge and pencil. Tape inside the pencil lines with painter's tape.

Brush two layers of acrylic medium (on a flat surface) or gel (on a textured surface) on the outside edge, allowing it to dry between layers. Stamp or paint on the edge and allow to dry; gently remove the tape.

Colored Border Effects

To create a sheer-color border effect, mix one-part acrylic paint with three-parts acrylic medium; brush the border with the mixture. For a darker border, let dry and repeat.

You can also apply sheer color by rubbing. Dab a little paint on a used dryer sheet or dry baby wipe; then apply it to your border.

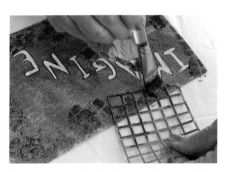

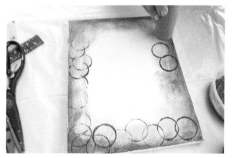

Stamped or stenciled borders can be created using a repetitive application or stenciling of found objects, such as the bottom of a plastic produce basket or the end of a cardboard toilet paper toll.

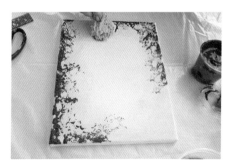

For an interesting textural border, apply opaque or mixed paint to sea sponge, and dab on the edges of the substrate.

Applied Borders

Borders can be placed evenly on all sides or broken up. Contrasting colors may be used for a more obvious border, or you can use similar colors and textures.

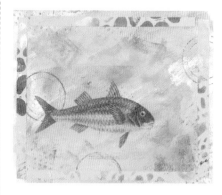

Scraps of painted paper, maps, napkins, and other printed paper materials make unique applied borders.

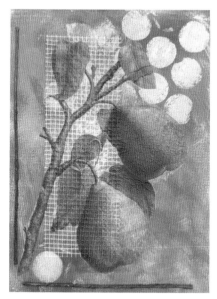

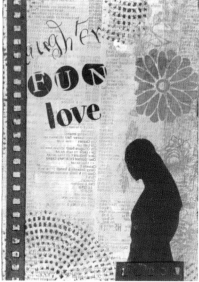

Film strips and punched-hole paper strips make great borders. Remove hole strips from a spiral notebook; paint and adhere with heavy gel.

Colorful strings, cords, and natural objects, including slender leaves and thin twigs, also make excellent borders.

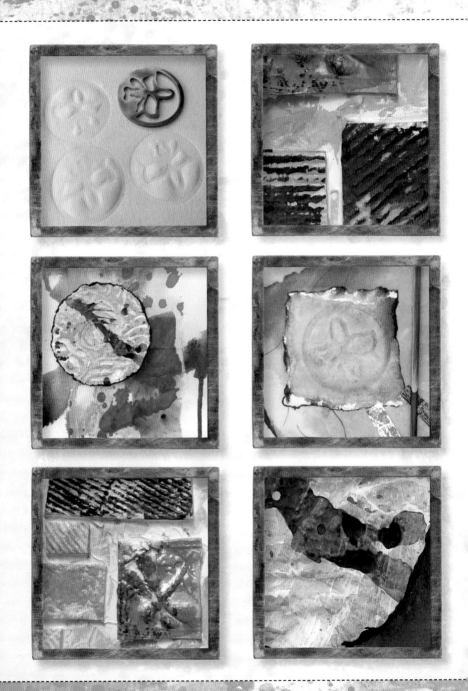

Embossing & Casting

with Cherril Doty & Marsh Scott

Painted cast and embossed pieces—either whole, torn, or cut into pieces—are an interesting way to add dimension and visual interest to your mixed media art. Favorite items can be cast and used to add a personal touch.

Materials

- Assorted papers
- Assortment of items for texture and pattern
- Towels (assorted sizes)
- Two large corrugated boxes
- Spray bottle or container of water
- Spoons (metal and wood)
- Blender
- Softest possible toilet paper
- Rack for drying
- Plastic needlepoint sheets
- Drying rack
- Dryer sheets
- Straight-sided shapes
- Rubber stamps
- Molds (e.g., shells, cookie forms, etc.)
- Silicone mat
- Hot glue gun
- 4" to 6" spring-form pan

Embossing

Embossing with a Vehicle

Strings, twigs, leaves, rope, stencils, and other soft textural objects are perfect for these techniques.

 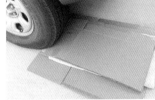

Step One Tear several sheets of paper to the width of your car tire or less. Moisten both sides of the paper with water, and stack paper inside a wet towel. Let rest for at least 20 minutes to soften.

Step Two Place one piece of flattened cardboard at the front of a tire. Place the embossing items in a single layer on top of the cardboard.

Step Three Remove the paper from the wet towel and place it on top of the items. Fold a large dry towel in half and place it on top of the paper.

Step Four Place a second piece of flattened cardboard over the towel. Now, drive back and forth slowly over the cardboard to make the impression. Carefully remove the paper and set aside to dry.

Embossing by Hand

Step One Tear several sheets of paper to the size you want. Wet the paper and place it inside a towel for 20 minutes or more.

Step Two Place a stencil or other textural embossing item on a firm surface. Place the paper over the item and a piece of plastic over the paper. Applying firm pressure, rub over it with a wooden or metal spoon.

Step Three Use your fingers to press in and around the design to further enhance it.

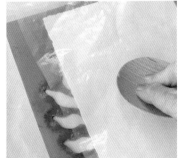 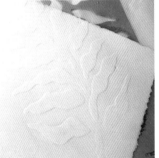

Handmade Pulp

When creating handmade pulp for casting, it is helpful to have a space where the water can drain through without damaging anything.

Step Two Spread dryer sheets over needlepoint plastic and slowly pour the pulp over it. Allow the water to drain through.

Step Three Gather some pulp with your fingers and press into a mold, pressing more into any thin areas, as needed. Place mold on a towel, pulp-side down, and let rest for 20 minutes.

Step One Gather your molds. Fill a blender about ¾ full of water. Tear a generous handful of toilet paper into bits and add to the water. Let it rest for 5 minutes; then blend for 10 seconds to a pulp.

Step Four Carefully loosen around edges and pull out your casting. When casting is dry, apply gesso to both sides of mold, and allow to dry completely. Paint or embellish mold, as desired; it is now ready to add to your work and can be adhered using regular glue.

Reusable Handmade Molds

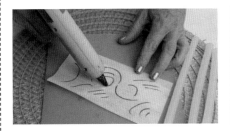
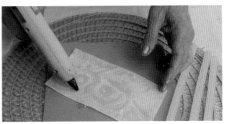

Step One Fold a dryer sheet in half, and draw a design on it using a pencil or pen. Place the sheet on a silicone mat; then trace over the design with a hot glue gun. Allow to cool and harden.

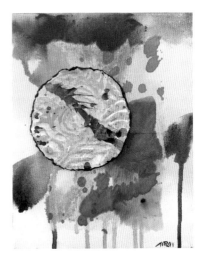

Step Two Prepare casting pulp (see page 17). Place the embellished dryer sheet face up on top of a needlepoint plastic sheet. Place a spring-form pan on top of the dryer sheet and then pour the pulp inside. Press down firmly, pressing the water out with your fingers.

Step Three Remove the mold, continuing to press out the water. Set the casting on a towel, and allow to air dry for 24 hours.

Step Four Follow step four on page 17 to prepare the mold for your art.

Found Objects

Outdoor Objects

There are so many interesting casting possibilities around us—a knothole in a fence, the cement marker, a design on a tree trunk. This method allows you to take your casting pulp with you.

Step One Create the casting pulp (see page 17). Pour pulp into a spring-form pan and press the water out as before. Repeat several times to create casting "patties." Place the completed patties in a sealed plastic bag to keep them moist. Use a range of forms to create casting patties in different sizes.

Step Two Take patties on the road and press them into any texture you like. Bring them home and let dry.

Household Objects

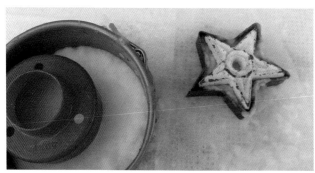

Step One Prepare casting pulp (see page 17). Pour the pulp, letting it drain as you go, into open molds, such as cookie cutters and a spring-form pan.

Step Two Press out the water using other objects, such as jewelry, buttons, and rubber stamps, to create texture.

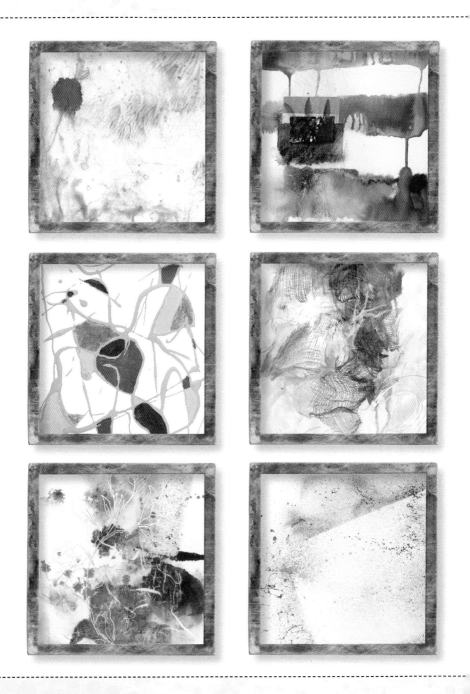

Drips, Drops & Sprays

with Cherril Doty & Marsh Scott

Jackson Pollack doesn't get to be the only one to play with paint! These techniques are just plain fun, and you can do them easily. Make sure your work area is well protected with tarps or plastic.

Materials

- Acrylic paints (heavy body and fluid)
- Acrylic and India inks
- Variety of spray paints
- House paint
- Spray bottle of water
- Variety of papers
- Canvas substrates
- Butcher paper
- Variety of paint brushes
- Toothbrush
- Pipette or eyedropper
- Protective tarp or old sheets

Drips & Drops

A roll of butcher paper is the perfect substrate for this playful technique.

Lay out a large sheet of paper and tape down the edges. Drip and drop paint or ink onto the paper randomly, in a controlled manner, or a combination of both. When done, gently fold the sheet over and blot lightly. Let dry.

Tip

Look around the sheet to find images hidden in the drips and drops. These may be perfect as they are, or you can draw into them.

Alternate Papers

Discover how drips and drops react on a variety of different papers.

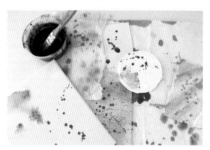

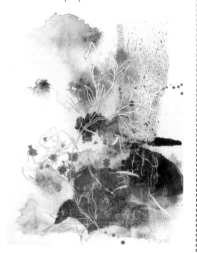

Gather rice paper, gampi, printing paper, watercolor paper, or other papers of varying weights and textures. Using the fluid acrylics and inks, drip and drop as demonstrated above. You will see that each of the papers responds differently to the paints and inks. Tear and use these papers in collage work.

Spatters & Drizzles

Brush Spatter

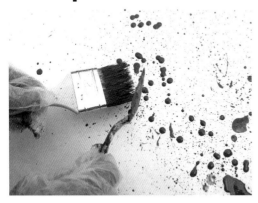
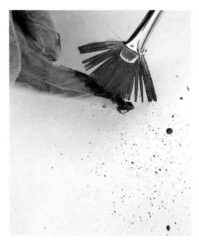

Dip your brush into paint; then use your finger or a palette knife to spatter it across the paper. Experiment with a variety of brushes, including a toothbrush. For variation, shake brushes over the paper.

Paint Drizzling

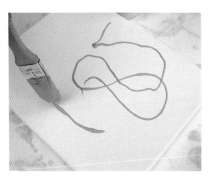

Tip

Moisten brushes near the base of the fibers before dipping into the paint; this makes brushes easier to clean.

This example uses dark-colored house paint. This can be mixed with 20 percent acrylic paint if desired. On a canvas substrate, using a one-inch brush, drizzle paint onto canvas to create an abstract outline. When dry, fill in the shapes, as desired, with colors to create your own Picasso-esque design.

Working with Water

Clear Water

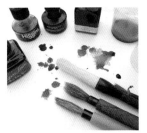 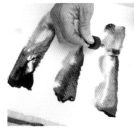 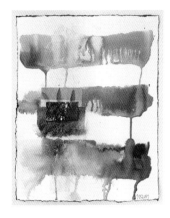

Step One Paint a design in clear water on water-media paper, working quickly.

Step Two Dip brush into ink and spatter, flick, or drop while also drawing back into the water lines. The ink will spread through some of the water areas. Large patches of painted water can create a marble effect.

Tip
This technique works best if the paper is not too absorbent.

Dissolving

Step One Paint a patch with heavy body acrylic paint on a canvas substrate, mixing your colors. (You could also add fresh paint to a finished work for this.) Allow a few minutes for the paint to begin drying before moving on to the next step.

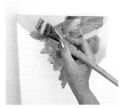 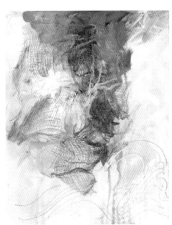

Step Two Use a spray bottle to mist the canvas with water. As the paint begins to dissolve and drip down the surface, spray back into the drips to create a different effect.

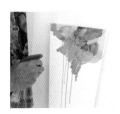

Sprays

In addition to traditional spray paints, there are a number of sprays on the market that can impart a variety of unique looks to your art, including glitter sprays, spray webbing, spray marbleizing, mists, and craft ink sprays. These sprays can be used to create singular effects or as an over spray.

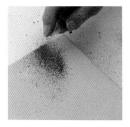

Tip
You can mix fluid acrylics with just a bit of water and use them in a spray bottle.

Place a large sheet of butcher paper down to cover your surface; then place your substrate on top. Experiment with a variety of sprays to see their effects. You may want to daub with a paper towel or baby wipe to achieve a slight diffused effect. After you finish spraying, lift the substrate to discover a negative image, which can be used to create yet another piece of art.

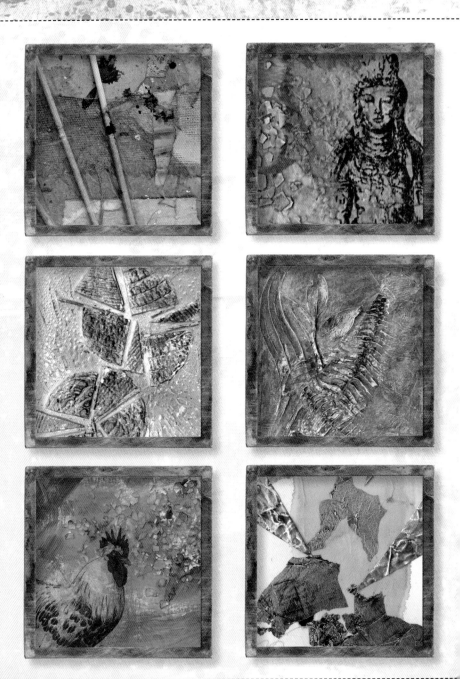

Aging & Antiquing

with Cherril Doty & Marsh Scott

At times we want to give a piece of art an aged or vintage appearance. There are several ways to achieve this effect: antiquing gels and patinas, abrading surfaces, and many techniques in between. Here are a few to help you get started.

Materials

- Several prepared substrates (partial or complete)
- Brushes
- Spray bottle filled with water
- Bronze or copper surface coating (for patina)
- Patina antiquing solution
- Metallic spray paint
- Paper towels
- Gold or copper composition metal leaf
- Acrylic medium and gel
- Plastic wrap
- Acrylic paints (gold to browns)
- Tea bags
- Strong coffee or tea
- Eggshells

Solutions & Sprays

These techniques should be done in a well-ventilated area.

Patina Solution

Step One Brush a metal surface coating of your choosing over the entire substrate or in specific areas. Allow to dry, but just barely.

Step Two Brush the patina solution gently over the surface (avoiding some areas to leave the original metal color). Place the piece in an area where it can dry slowly. It may take 2 to 6 hours for the patina to develop.

Step Three When dry, seal the surface with acrylic medium or spray.

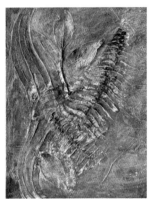

Metallic Spray Paint

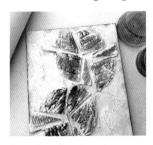
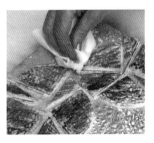
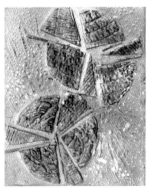

Step One Coat the substrate with gel, medium, or paint.

Step Two Spray water over the entire surface.

Tip
Bronze, antique gold, and copper are good choices for metallic spray paint.

Step Three Shake the paint can thoroughly, and spray the surface of your substrate. Immediately blot with a paper towel. Let dry.

Gold Leaf

The chemical changes that take place with this method give the gold leaf an antique appearance.

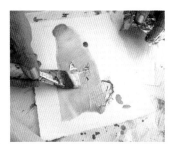

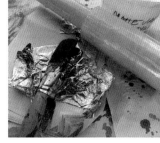

Step Two Tear off a piece of plastic wrap. Drop it over the gold leaf area you wish to antique. Do not rub or press. Set it aside for 20 minutes.

Step One Brush acrylic medium where you want to place the gold leaf. Cut or tear the leaf and drop into place. With a soft brush gently coat the surface with the medium. Wait one minute.

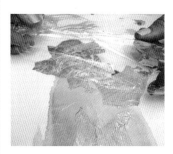

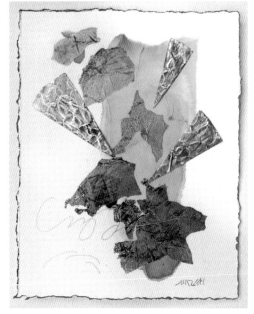

Step Three Carefully remove the plastic. The full result will not show until it is completely dry.

The gold leaf in the upper half shows no effect where the plastic is not used, whereas the lower half shows the aging effect created when the gold leaf is covered with plastic wrap.

Paints Used to Age

This technique works well for antiquing a painting or a photo. For best results, the surface should be nonabsorbent, so make sure to coat the piece with acrylic gel or medium.

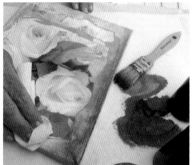

Step One Dampen a paper towel. Brush a small amount of paint on the surface of the piece. Start at the edge, scumbling the paint around. Before the paint dries, rub it to blend. If the result is too dark, blend medium into your paint colors.

Step Two Darken the corners more than the rest of the piece. If the paint is too light in any area, allow it to dry and repeat the process.

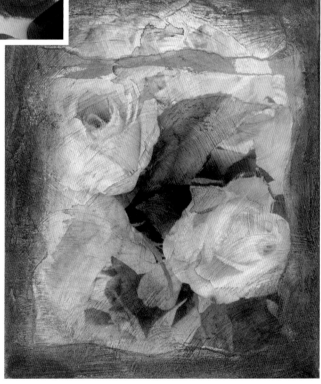

Used Tea Bags

Tea and coffee have a wonderful effect in aging a piece. Sprinkle tea and coffee grounds on a work for speckles of dark color. While there are many techniques using tea bags, below we discuss their use as a background.

◄ Step One Brew a strong batch of tea and set the bags aside to dry completely.

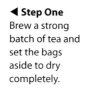

Tip
Avoid using white or green teas, which will not produce rich color. Try berry teas for a different effect, as well.

► Step Two When dry, carefully remove the staple and string, and empty the tealeaves. Unfold the bags to lay flat.

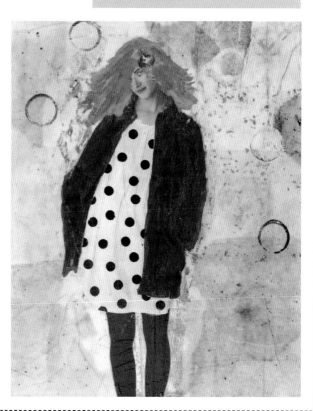

▲ Step Three Use acrylic gel to adhere the unfolded bags to your substrate and then let dry. The background can then be stamped, stenciled, collaged over, painted on…you name it!

Steeped Tea & Coffee

The stains achieved in this method create an aged effect.

Step One Brew a batch of strong coffee or tea (three or four bags).

Step Two Brush, spray, soak, or dribble the coffee or tea liquid over absorbent papers or collage materials. Let dry and repeat as needed.

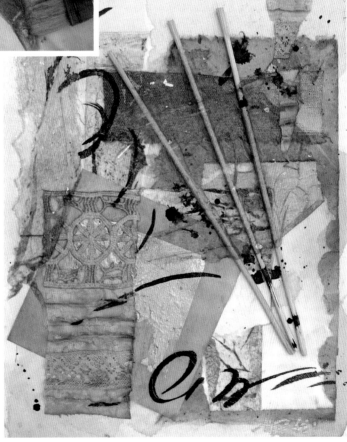

Eggshell Crackle

Save eggshells and crush them to smithereens!

Apply eggshells with gel medium to a painted or unpainted background for an aged, crackled appearance.

Paint over the eggshells and allow to dry. Then brush over the piece with acrylic medium and add thin tissue-like paper pressing down lightly.

Pens, Pencils & Pastels

with Cherril Doty & Marsh Scott

As more artists embrace mixed media, the market has rushed to keep up, adding a vast number of pens, pencils, and pastels beyond what traditional artists have used. Search online or check out your local art store for a variety of options!

Materials

- Watercolor paper, mat board, or canvas
- Container of water
- Brushes of various sizes
- Ink pencils or watercolor pencils
- Metallic and other permanent markers
- Charcoal and charcoal pencils
- Conté crayons
- Oil pastels
- Water-soluble oil pastels
- Spray workable fixative
- Acrylic gel
- Smudge sticks
- Assorted papers: writing, drawing, translucent, deli, rice, gampi, tissue, etc.
- Magic Rub® or art gum eraser

Ink & Watercolor Pencils

Ink and watercolor pencils can create new themes in your artwork with image transfers or collages. Here we show how to draw back into an inkjet transfer to complete a piece of art.

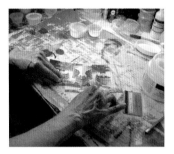

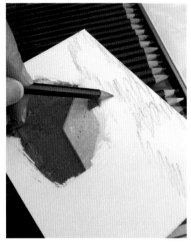

Step Two Draw into the piece with ink or watercolor pencil to complete the scene in the photo.

Step One Inkjet transfer an image onto watercolor paper or mat board, and spray with a workable fixative. For more information, see "Transferring" in *101 Mixed Media Techniques* (Walter Foster Publishing, 2014).

Step Three Dip a brush in water and brush across the drawn parts. Smudge with your fingers as you go. Add more color as needed.

Permanent Markers

Choose an acrylic painted surface (abstract or representational). Use permanent markers to outline, color into, or create a sketch. You can also use the markers to write words into the piece.

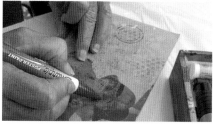

Tip
Permanent pens and metallic markers can write on almost any surface.

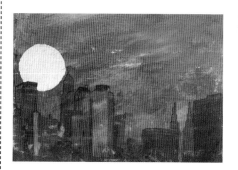

Conté Crayons & Charcoal

Traditionally, Conté crayons, charcoal, and pastels (opposite page) are used in figurative drawings. For mixed media, we use them to soften and shade collage and photo work.

Spray your piece with a workable fixative and let it dry. Draw back into the work with a Conté crayon, charcoal piece, or charcoal pencil to define lines, highlight, draw details, or create shadows. Smudge as needed to blend. Smudging will give a hand-drawn look to photo or transferred images.

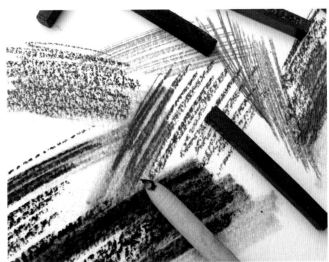

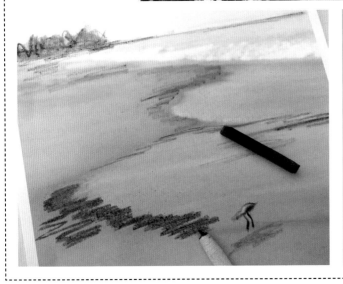

Tip

Conté crayons are harder than charcoal. Both can be smudged, but Conté crayons will spread more easily with smudge sticks. Charcoal is easily smudged with fingers.

Pastels

Tip
Water-soluble oil pastels are similar to water-soluble pencils; they have a softer effect when lightly moistened or smudged with fingertips.

Use colorful pastels to draw back into and highlight photos or collage pieces.

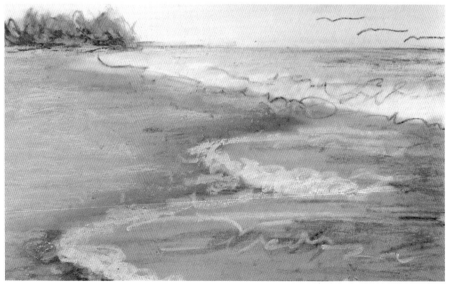

Translucent Papers

Writing or drawing on a piece of nearly finished work can be tricky. One way to avoid errors is to draw on a translucent surface first; then adhere it to your piece with acrylic gel. Translucent papers can also add an additional layer of texture.

Step One Write or draw on the translucent paper of your choice, and tear around the edges.

Tip
Apply a light wash of acrylic paint to the paper before writing or drawing on it.

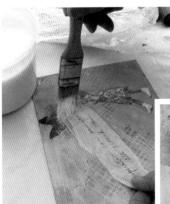

Step Two Apply acrylic gel under and over the paper and adhere to the substrate, smoothing with a brush and your fingers.

Distinctive Backgrounds

Fill Patterns

Drawing distinctive fill patterns can create texture and add visual interest to backgrounds. Use fill patterns to create a design or highlight aspects of your piece.

Pencil in the pattern first and then fill it in by stippling, cross hatching, or stenciling. Next, shade the pattern with pen. Pencil lines can be erased using a soft eraser like Magic Rub® or art gum.

Words, Numbers & Symbols

Use permanent pens, markers, and pencils to write and doodle all over a piece for background interest—or just for fun!

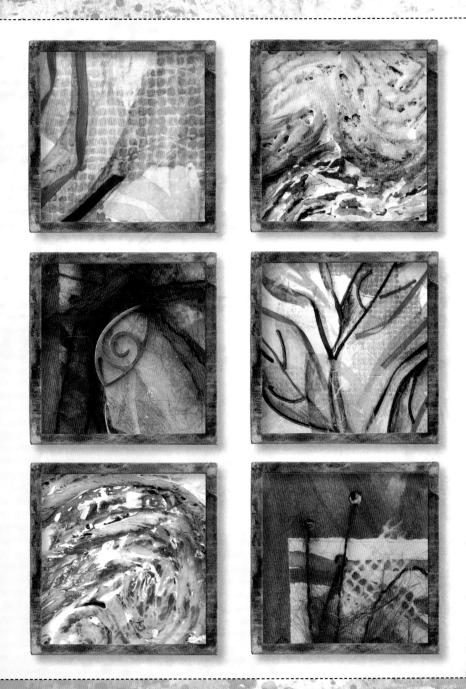

Yarn & String

with Cherril Doty & Marsh Scott

There are several ways to use yarn and string in mixed-media artwork. It can be laid down as a textural background, used for dimensional outlining, or utilized as "drawing" material. You can also use yarn and string to create abstract or representational images or to hand-sew onto a piece for visual interest or highlighting.

Materials

- Yarn, string, embroidery floss, ribbon, cord, paper ribbon, twine, etc.
- Heavy and medium acrylic gel
- Acrylic medium (matte or gloss)
- Painted substrates, such as canvas, board, or heavy paper
- Scissors
- Container of water
- Pencil
- Spray bottle of water for wetting
- Wood glue or white glue
- 1" brushes
- Pushpins
- Awl or nail tool
- Hammer
- Small block of wood
- Tapestry needle
- Hot glue gun

Dimensional Outlining

Step One Select your outline material such as ribbon or cord. Use a pencil to draw the design on your chosen painted substrate.

Step Two Wet the ribbon or cord to make it malleable.

Step Three Use a brush to cover the surface with the acrylic gel.

Step Four Lay the ribbon or cord over the design and press down with your fingers. Add more gel if necessary (it will dry clear). Continue adding ribbon or cord to complete your design. Let dry.

Step Five When completely dry, cover the entire piece once more with gel.

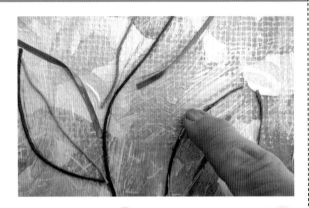

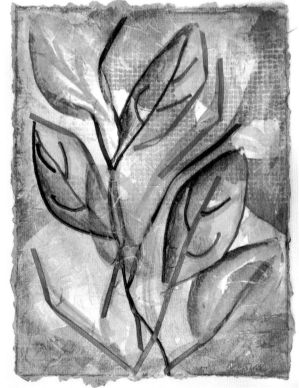

Tip
Apply hand lotion to your hands before beginning this technique. It will make cleaning your hands easier when you are finished!

Textural Background Swirls

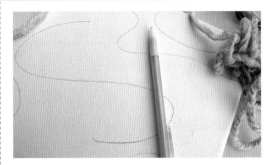

Step One Sketch a simple swirl design on a rigid substrate. Wet the string. Cut pieces of yarn or string in a variety of lengths from ¼" to 8".

Step Two Apply glue to the longest line of your design. Arrange the longest pieces of string over the main lines. Continue to cover your design with the shorter pieces.

Step Three Once the main design is completed, begin filling it in by repeating lines using smaller and smaller pieces. Any gaps can be filled in at the end with ¼" or ½" pieces.

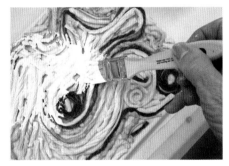

Step Four When thoroughly dry, apply two or three coats of gel. If you used colored string, use medium gel (it will dry clear).

Tip

At about the halfway point, take a break to let the piece dry. When completed, let dry overnight or longer.

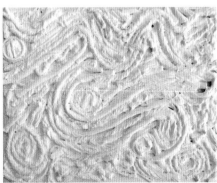

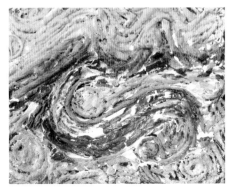

Sewing with Yarn & String

Use a blank canvas or heavy paper substrate to "sew" or "paint" (see opposite) with colorful yarn, embroidery floss, or ribbon.

On a painted substrate, use a pencil to mark dots in groups of three to indicate where to punch holes. Lines can run side-by-side or crisscross. Place substrate on a wood block and use an awl or a nail tool to punch holes just large enough for the needle to pass through. Cut three pieces of yarn or string three inches longer than each line you wish to create. Thread the needle and pass through the holes as desired; tack the yarn in place on the back with a hot glue gun.

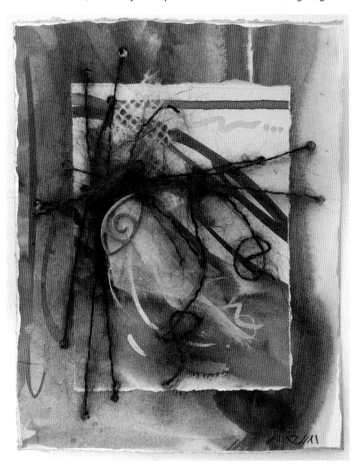

Painting with Yarn & String

Step One Apply heavy gel over the entire substrate with a brush.

Step Two Set the ribbon onto the gel and press firmly with your fingers. You can also wrap the ribbon or floss around the entire canvas. As you continue, you may stop to let the pieces dry if they begin to move too much.

Step Three Drop in small pieces of ribbon or floss to fill in blank areas or to create accents.

Step Four When finished, coat the entire piece with an acrylic medium or gel.

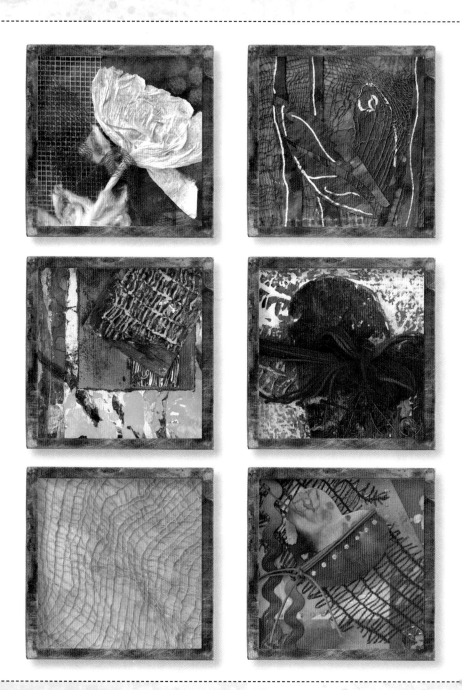

Fabrics & Fibers

with Cherril Doty & Marsh Scott

As you continue working in mixed media, the list of materials will seem endless! There are an abundance of fibers and fabrics that lend themselves easily to creating texture, visual interest, and dimension to your artwork.

Materials

- Cheesecloth
- Gauze (rolls, 4" squares)
- Acrylic paints
- Substrates (canvas, mat board, or watercolor paper)
- Assorted fabrics (lace, burlap, etc.)
- Wood or cardboard cutouts
- Assorted unique fibers (produce bags, dryer sheets, drywall tape, etc.)
- Scissors
- Acrylic medium
- Acrylic gel
- Gesso
- Container of water
- Plastic-covered cardboard
- 1" brushes
- Staple gun

Colored Cheesecloth

Fabrics and fibers are wonderful for adding texture and dimension to mixed-media art.

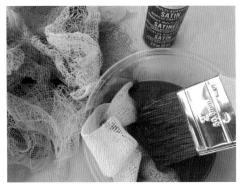

Step One Color cheesecloth or gauze by mixing one part acrylic paint and one part water in a small container. Dip small pieces of cheesecloth into the mixture; spread them on top of plastic or hang them to dry.

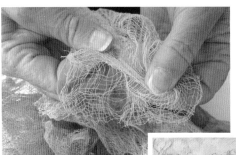

Step Two Once dry, cut, pull, or tear the cloth into pieces to use for textural backgrounds or as highlights on your artwork.

Textured Backgrounds

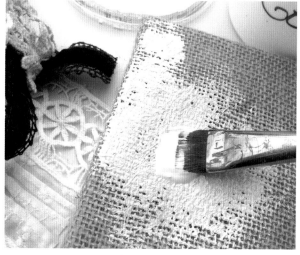

Step One Brush a thick layer of gesso onto your canvas. Lay burlap or other textured fabric onto the gesso while it's still wet. Staple the burlap to the back of the canvas.

Step Two Brush a coat of gesso over the top, flattening the burlap as you go. Let dry.

Step Three Follow the same steps to add more layers, if desired, allowing each layer to dry before you add the next. When all layers are dry, finish your artwork.

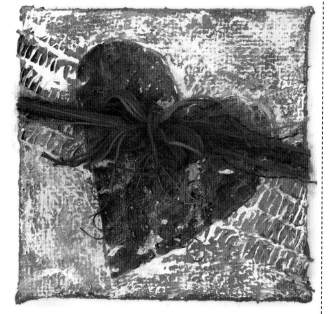

Tip
For best results, apply gesso liberally.

Printed Backgrounds

Cut out fabric pieces in simple, repetitive shapes, such as circles, squares, waves, and straight lines. Starting at one edge of a rigid substrate, spread gel or medium. Press the fabric down. Don't worry about the fabric going over the edges of the substrate. Lay down each piece, overlapping as you go, brushing gel over and under them.

Tip

Craft stores have bundles of pre-cut fabric swatches in related colors and patterns. Use both sides of fabric for variation, if desired.

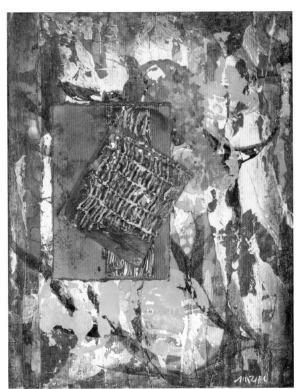

Stiffening & Cutting Fabrics

Step One
Cover a piece of cardboard with plastic; then brush acrylic medium over the surface of the plastic.

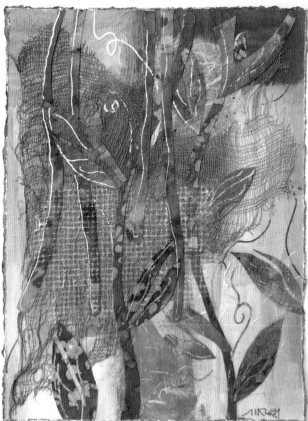

Step Two Press fabric pieces flat on the plastic, adding more medium as needed. Brush medium over the fabric pieces again, covering the entire surface. Let dry. (Medium will turn clear when dry.)

Step Three When dry, loosen the corner of each piece and peel off the plastic. Cut the fabric into shapes, and draw or write on the pieces, as desired.

Tip

Use both positive and negative shapes from the cut fabric pieces in your artwork.

Fabric Wraps

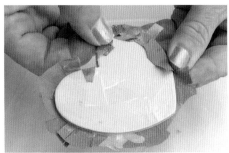

Step One Brush medium over a cardboard or wood cutout. Apply one or more pieces of fabric across the cutout, and cover with medium. Let dry.

Step Two When dry, turn the cutout over so the backside is face up. Trim the fabric, leaving a quarter inch around the edges. Make little cuts up to the edge of the shape all the way around. Brush medium on the back of cutout and wrap the fabric around, brushing on more medium as needed.

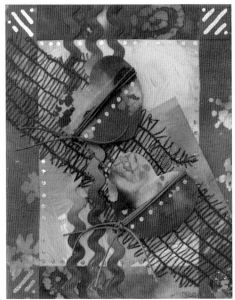

Step Three Let dry. Use the shapes as dimensional pieces in your artwork.

Unique Fibers & 3-D Effects

Creating Texture Using Found Fibers

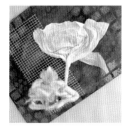

◀ **Step Two** On a separate board or paper, experiment with using these various fibers. Some will be adhered easily with acrylic medium, while others will require heavier gel. Once you are familiar with these fibers, use them in your artwork.

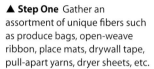

▲ **Step One** Gather an assortment of unique fibers such as produce bags, open-weave ribbon, place mats, drywall tape, pull-apart yarns, dryer sheets, etc.

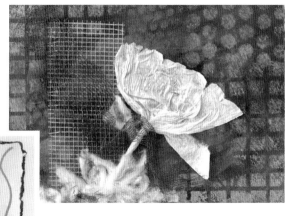

3-D Fabric Effects

Twisted and scrunched scraps of fabric can be tied or wrapped and then added to a card with a couple of quick stitches for a 3-D effect.

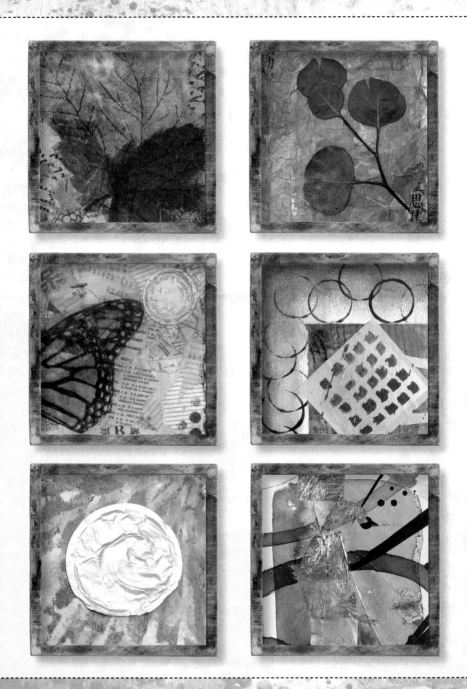

Using Metals

with Cherril Doty & Marsh Scott

There are a number of ways one can use various types of metals in mixed media, especially when working in 3-D. Here, we offer a few of our favorite 2-D possibilities.

Materials

- Soda can
- Clear gesso
- Fluid acrylic paints
- Thin papers (napkins, tissue, etc.)
- Mat board
- Spray paint
- Awl or large nail
- Hammer
- Candy foils
- Acrylic soft gel
- Acrylic medium
- Bone folder or spoon
- Tin wine caps
- Brads or small, short nails
- Tin snips or old scissors
- Wood substrate
- Paper or canvas (painted or unpainted)
- 1-inch brush
- Soft watercolor brush
- Scissors
- Joss papers
- Metal leaf
- Aluminum foil

Candy Foil Accents

Carefully remove the foil and eat the candy. Smooth the foil with a bone folder or spoon. If desired, cut the foil into shapes. Attach the foil pieces to your artwork with acrylic soft gel, and smooth down with your fingers.

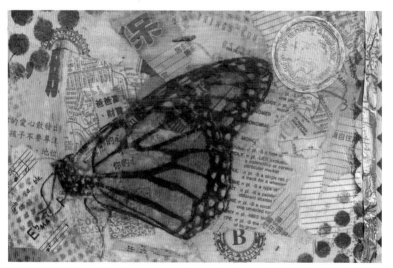

Tip
Wrappers from candy coins, bars, or baker's chocolate will work well for this technique.

Candy Foil Backgrounds

We like the texture provided by the folds from small square candy foil wrappers.

Step Two Use fluid acrylic to paint over the foil. We like metallic paint with the foils. Add collage pieces if desired.

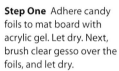

Step One Adhere candy foils to mat board with acrylic gel. Let dry. Next, brush clear gesso over the foils, and let dry.

Tip
We like using clear gesso over the foils before they are painted or collaged, as it makes the surface a bit more tacky and better able to receive the paints and gels.

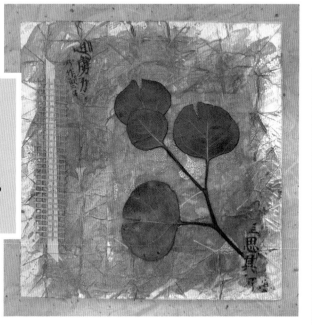

Salvaged Metals

You can use aluminum soda cans and other thin metals in a variety of interesting ways. Here is an excellent 2-D example of using a soda can.

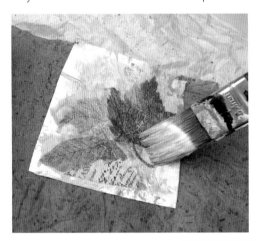

Step One Cut the can with tin snips to whatever shape desired. Flatten and distress the can by hammering.

Step Two Brush clear gesso onto the can and let dry.

Step Three Drop fluid acrylic paints onto the can randomly, and let dry (we suggest metallic colors).

Step Four Adhere tissue, napkins, or other thin papers to the can with acrylic gel.

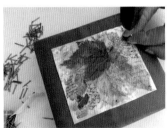

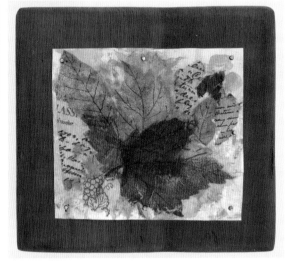

Step Five When dry, adhere to a wood block with small brads for a finished piece.

Joss Papers

Joss papers, or "ghost money" in Asian cultures, are paper squares with metallic silver, gold, or copper rectangles. You can paint, stamp, write, or draw on them.

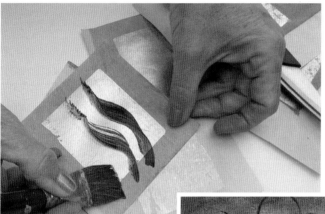

Cut or tear Joss papers as desired, embellishing them with paint or marker. Use acrylic medium to apply them to your piece.

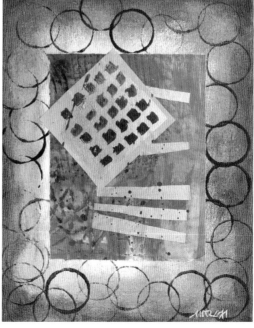

Using Metal Leaf

Make sure you are in a wind-free area when you use this technique, as metal leaf is very thin and delicate.

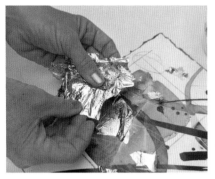
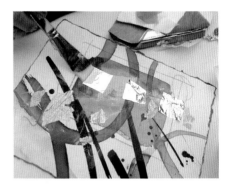

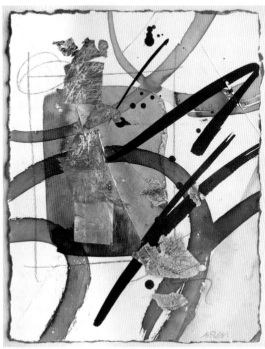

Step One Brush acrylic medium on your painted substrate. With clean, dry fingers, tear or cut the metal leaf and drop onto the substrate.

Step Two Using a soft watercolor brush and a light touch, brush acrylic medium over the top of the metal leaf.

Tip

When cutting the metal leaf, leave it between two of the paper layers within the metal leaf book. This will prevent the metal leaf from sticking to your fingers and tearing.

Foil & Metal Rubbings

Textural aluminum pieces, when painted, can add shine and interest to your artwork. Metal also can be used to create rubbings using pastels, Conté crayons, etc.

Aluminum Textural Pieces

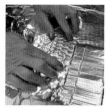

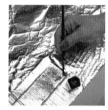

◄ **Step Three** Paint a small area of the foil with hobby paints. Add a few drops of thinner and with a paper towel rub across the paint.

Step One Gather an assortment of textural pieces, such as cookie press inserts, rug backing, stencils, flat jewelry pendants, leaves, etc.

Step Two Cut a sheet of heavy foil and place on top of your items. Using fingers or a pencil eraser, gently press down to create the pattern.

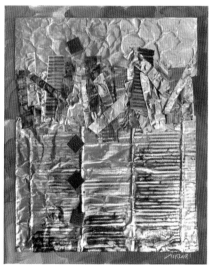

Metal Rubbings

Metal shapes, such as this leaf ornament, can also be used to create rubbings. This one was done on deli paper. Try using an assortment of colors, and layer the rubbings in your art pieces.

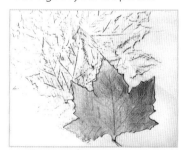

sible to ex
ing a bird

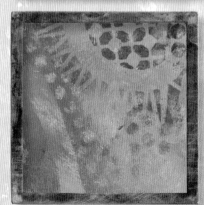

Resists & Masking

with Cherril Doty & Marsh Scott

The use of resists and masks can add a great deal to artwork—visual interest, the appearance of texture, and more. There are many products that are marketed just for this purpose; however, you can create your own using a little ingenuity and things you most likely already have in your basic supplies.

Materials

- Rubber cement
- Art gum eraser
- Brushes
- Purchased stencils or masks
- Acrylic paints
- Cosmetic sponges
- Scissors or scalpel
- Masking film
- Pencil
- Manila folder
- Magazine images
- Crayons
- Watercolor paper
- Watercolors

Rubber Cement

Rubber cement works in the same way as masking fluid. This resist technique preserves layers beneath a painted surface. Watercolorists use this technique to preserve white areas.

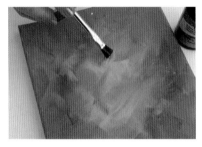

Step One Paint the rubber cement in the design you'd like to preserve and let dry.

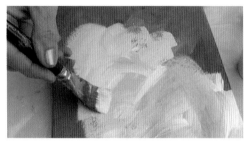

Step Two Paint over the rubber cement with thinned paints.

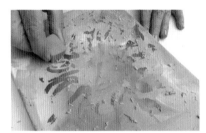

Step Three When the paint is dry, rub the surface with an art gum eraser to remove the rubber cement. If the rubber cement is thick, you can peel it off by hand.

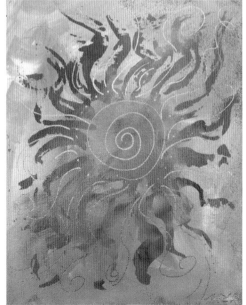

Tip
For thinner lines, thin rubber cement with acetone.

Stencils & Masks

Stencils

You can use the inner portion of the stencil as a mask or simply on its own for a repeating pattern or outline.

Step One Lay the inner portion from your stencil on top of a painted surface. Lightly tape down a corner to help keep it in place.

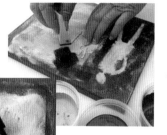

Step Two Apply paint in a solid color around the mask using cosmetic sponges. You can repeat or reverse the mask across the surface to create a pattern.

Tip
Use permanent marker to add special words or phrases to masked areas for a custom lettered-art look.

Masking Film

Masking film is a flexible, low-tack film. You can draw on it or simply cut out shapes to use as masks with scissors or a scalpel. Once your shapes are cut out, they can be adhered to a painted substrate or you can follow step two above to create a reverse outline.

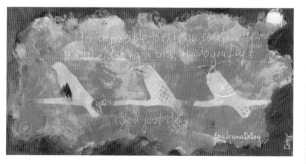

Magazine Images

For those who do not consider themselves to be traditional artists, this is an easy way to introduce figures into your mixed-media work.

Step One Find an image from a magazine that you would like to use in your piece. Using acrylic gel, adhere it to a manila folder.

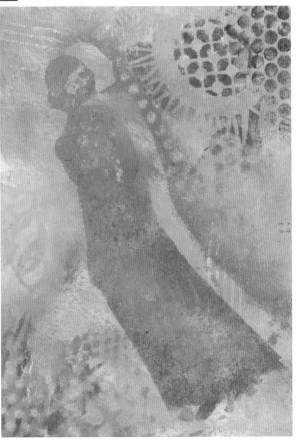

Step Two Carefully cut around the image with scissors or a scalpel. You now have a stencil and a mask to use repeatedly in your work.

Tip
Try mixing stencils and masks to create layered, shadowy images.

Wax Resists

Wax resists create a loose and sketchy feel. While there are many ways to use wax resists, the simplest technique can be done with a box of crayons.

Step One Draw an image or design using crayons.

Step Two Brush on a wash of watercolor paint using one or several colors. The crayon line allows you to easily paint right up to the edges without bleed.

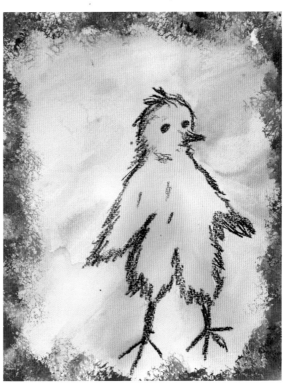

Tip
Use a combination of crayon and watercolors, and layer using stencils and masks for a dynamic mixed-media look.

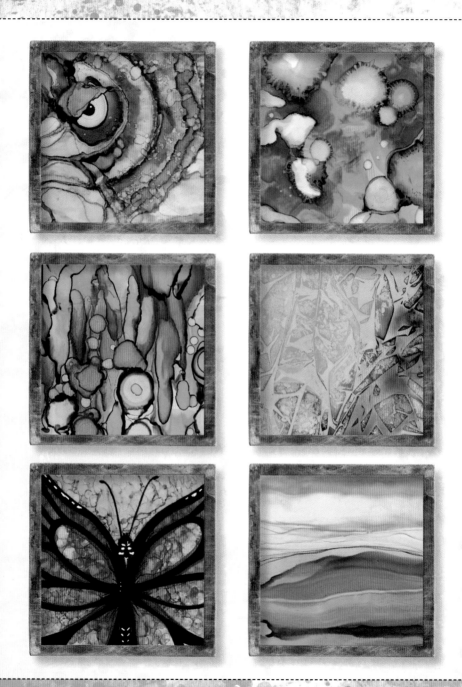

Alcohol Inks

with Monica Moody

Alcohol inks are acid-free, fast-drying, highly pigmented inks that are ideal for many mixed-media applications. They are intended for use on nonporous substrates, such as synthetic paper, glossy paper, glass, plastic, and metal, so the vibrant colors retain their intensity. Blending ink colors and adding isopropyl alcohol or alcohol blending solution can produce stunning effects. Although the inks have a thin viscosity, texture can be simulated using common household painting items. The unexpected "movement" of alcohol inks makes them especially fun for abstract works. With patience and practice, representational painting is possible, often with quite intriguing results.

Materials

- Alcohol inks (at least three colors)
- 91% isopropyl alcohol or alcohol blending solution
- Yupo® synthetic paper (74lb, 100lb, or 144lb)*
- Paintbrushes (small detail brushes)
- Cotton swabs
- Eyedropper
- Paper towels
- Cling wrap
- Masking fluid or frisket
- Freezer paper or other protective cover
- Wooden stamp with felt strips
- Rubber cement pick-up
- Black pens or markers
- UV resistant clear coating

*Each technique in this section is demonstrated on a 5" x 7" sheet of 144lb paper. Synthetic paper is preferred for alcohol ink painting. You may also wish to try glossy cardstock, glossy photo paper, Terraskin® paper, Claybord®, or hardboard covered in gesso. Results will vary with each type of surface. Other nonporous surfaces suitable for painting with alcohol inks are shrink film, acetate, glass, metals, plastic, polymer clay, melamine, ceramic tiles, and wax paper.

Dripping & Dropping Ink

Some of the most fun you can have with alcohol inks is simply to drip them onto a surface right from the bottle! As you randomly drop and splatter inks, you'll quickly begin to notice how the different colors react as they meet. In many cases, dark lines may appear where two or more different colors touch. Depending on your preference, you can attempt to subdue this by adding a touch of 91% isopropyl alcohol (or an alcohol blending solution) to a detail brush and lightly going over the area. Don't rush to remove those dark intersections until you've experimented and are happy with your composition. Sometimes those unintentional lines create interesting paths!

Alcohol (and alcohol blending solution) is to alcohol inks as water is to watercolor. You can use it to blend and lighten the inks. For this simple experiment, simply drip and drop some alcohol from an eyedropper on top of ink and watch the magic happen!

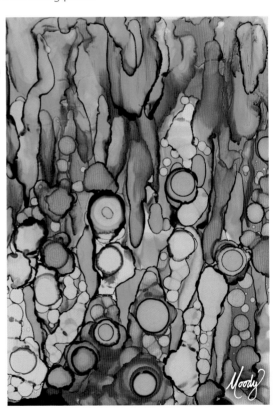

Tip

Tilt your paper or surface around for some wonderful, drippy effects. Cover your work station with freezer paper (shiny side up) and use a paper towel to catch the ink that drips off of the paper.

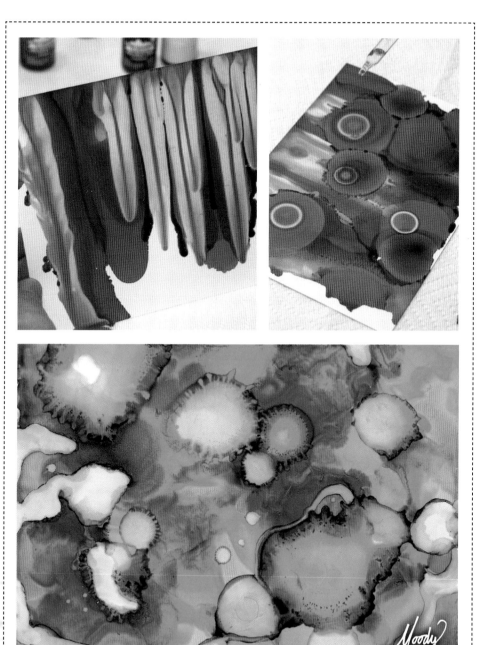

Abstract Landscapes

This abstract features a simple three-color combination. By adding alcohol, you can blend and lighten colors and create "washes." It's also possible to create a one-color ink painting by using alcohol (or alcohol blending solution) to produce different values.

Tip
Work quickly! Alcohol inks dry fast. You can reconstitute dried ink by adding more alcohol to it.

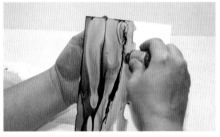

Step One Drip ink directly from the bottle onto the paper; allow to run off the other side. Add multiple drips of the same color for a layered effect.

Step Two Repeat with another ink color (in this case, a lighter shade of green). Allow the two colors to run together.

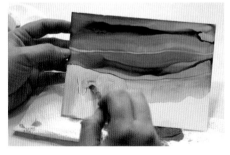

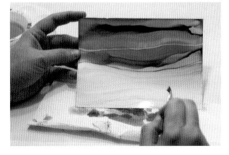

Step Three Turn the paper so that the "horizon" is at the bottom. Run a drip along the horizon and allow the color to drip off the paper.

Step Four Using a brush wet with alcohol, make strokes horizontally to blend and create the sky.

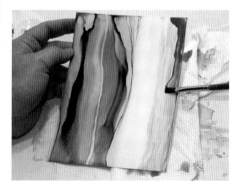 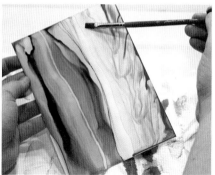

Step Five Add a darker color to the top edge to add to the sky.

Step Six Dip a brush in alcohol and go over the darker color. Tilt the paper a bit to allow the ink and alcohol to move.

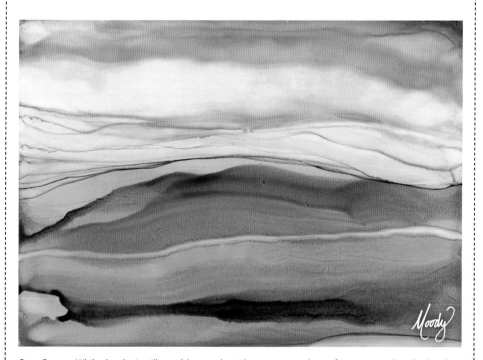

Step Seven While the sky is still wet, blot gently with a paper towel to soften areas and imply clouds.

Concentric Circles

Concentric circles are circles that have the same center, fit inside each other, and are the same distance apart. Using alcohol (or alcohol blending solution) to remove alcohol ink from a surface is called "lifting."

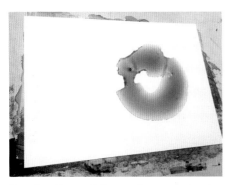

Step One Draw a circle onto the paper using the tip of the ink bottle.

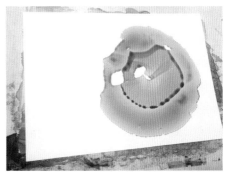

Step Two Using a different color, repeat the process, creating another circle around the first.

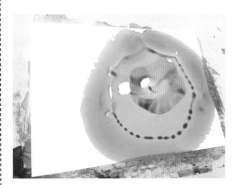

Step Three Repeat with a new color.

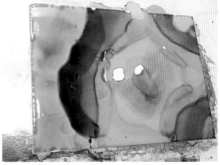

Step Four Repeat again, alternating colors if you like, until you've covered the entire piece of paper.

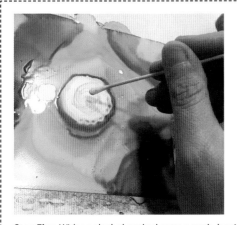
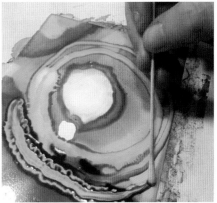

Step Five With an alcohol-soaked cotton swab, begin to work around your circles again. Go back over the concentric circles with the cotton swab until the entire paper is covered.

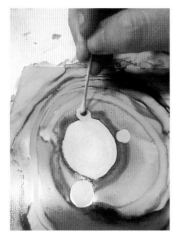

Step Six Add interest by lifting other small circles or dots with the cotton swab. Lift the ink from inside the innermost circle.

▶ **Step Seven** Create a focal point by dropping a coordinating (or opposing) color into the center circle you made, lifting the ink out.

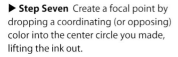

Cling Wrap Effects

Cling wrap can add some very interesting and dynamic effects when combined with alcohol inks. Wad it up into a ball to "stamp" texture on top of the ink or, as in this technique, use it to cover a large section or an entire painting.

Tip

Do not lift the cling wrap to peek! This technique takes a long time for the alcohol inks to set and dry under the cling wrap. Wait at least overnight, preferably 24 hours, before you remove the cling wrap from the paper.

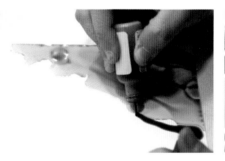 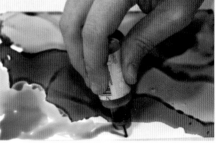

Step One Begin by squirting ink in random lines or shapes directly from the bottle.

Step Two Add more ink in different colors until the entire paper is covered.

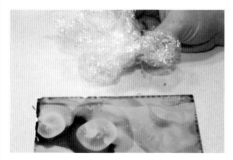 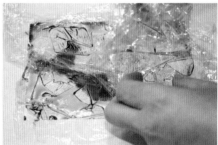

Step Three Tear off a sheet of cling wrap measuring the size of your painting, preferably larger. Crinkle it into a tight ball.

Step Four Unroll the ball of cling wrap, and place it on top of your painting.

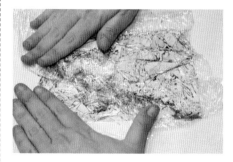

Step Five Press the cling wrap down evenly over your painting. Pull the cling wrap tight and smooth.

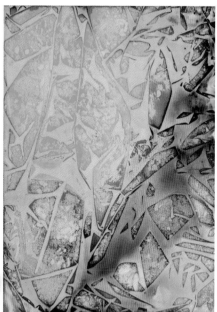

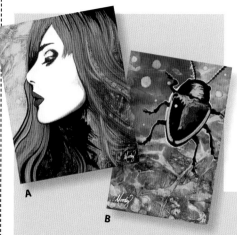

A

B

Step Six Let dry overnight, preferably 24 hours, before removing the cling wrap.

More Examples

In image A, cling wrap was used for the green background and the first couple of layers of hair. Strands of hair were painted over and worked into the texture that was left behind after removing the cling wrap.

In image B, the beetle was added to a clingwrap background. The main shape of the insect was lifted with alcohol and cotton swabs, and then drawn with marker and gel pens. Detail brushes were used to color the beetle with alcohol ink.

Masking Fluid

Masking fluid (or frisket) can be used with alcohol inks to preserve areas of the paper you wish to remain white. It's also useful if you prefer to paint backgrounds before subjects. Masking can be done in multiple steps or layers. You can mask an entire subject, paint the background, and remove the mask. Add masking fluid back to the areas of the subject where you want to retain white or add lighter details later. See the step-by-step example below for using masking fluid to create a field of aspens.

Tip
Before applying masking fluid, dip or coat your brush with liquid dishwashing soap. The soap should prevent the masking fluid from drying or clumping on the brush (and ultimately, ruining the brush).

Apply masking fluid to the areas you wish to keep white.

Once the masking fluid is completely dry, begin to add ink to your painting.

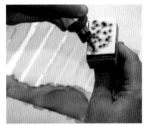

For a special effect, add light green ink to a felt strip on a wooden stamper.

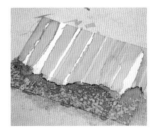

Stamp the lighter green ink on top of the dried dark green ink. For this effect, be sure to turn the stamper with each "stamp" to keep the pattern random.

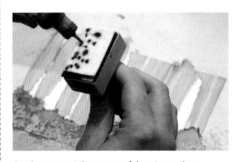

Apply orange ink to a new felt strip on the stamper to add more details.

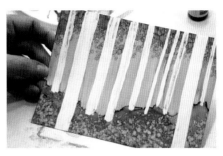

Once the ink is completely dry, remove the mask.

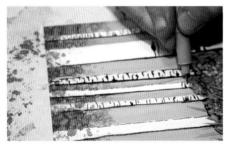

Using a pen (.01 tip), add details to the aspen trees.

Tip

To remove the mask, use a rubber cement pick-up to begin the lift, and do the rest by rubbing or peeling it with your fingers.

You can add "grass" and more details to the ground with the lighter green ink, alcohol, and a detail brush.

Combining Pens & Alcohol Inks

Alcohol inks can be used in conjunction with pens and markers. The steps below detail a common process for creating a "painted illustration" using pen and alcohol inks.

Tip

Alcohol inks spread easily, and a little goes a long way when stippling with cotton swabs. Layering and blending different-colored dots of ink with cotton swabs can produce interesting effects. Keep a piece of scrap paper nearby for testing.

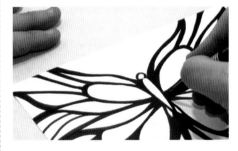

◀ Sketch a butterfly with pencil, and then use a black marker to ink the drawing.

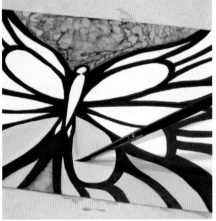

▶ Paint the background with blue alcohol ink, first in a somewhat "solid" layer, and then dotted with a detail brush in the same color. Next add yellow and gold alcohol inks with a detail brush as a base layer for the wings.

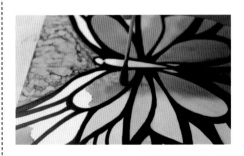

◀ Dab in orange alcohol ink with a cotton swab.

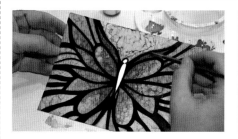 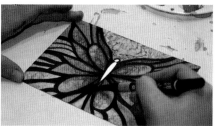

Continue stippling with orange and rust alcohol inks, layering and blending dots. Darken a few areas by mixing a little red alcohol ink with the rust color.

Despite best attempts to stay "within the lines," alcohol inks inevitably end up running into black areas. Go back over the black lines with your marker or pen after the alcohol inks are complete and dry.

Tip
When finished, spray your alcohol ink paintings with a UV-resistant clear coating in a gloss finish. This not only protects alcohol inks against UV light but also enhances the consistency and appearance of black lines made by markers and pens.

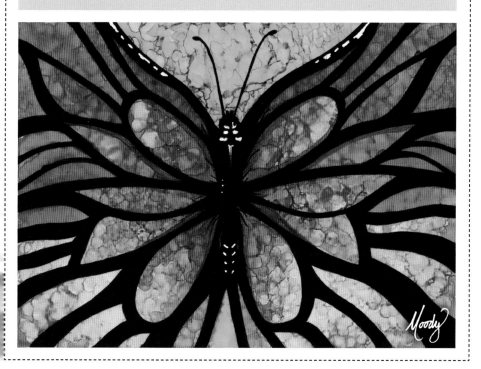

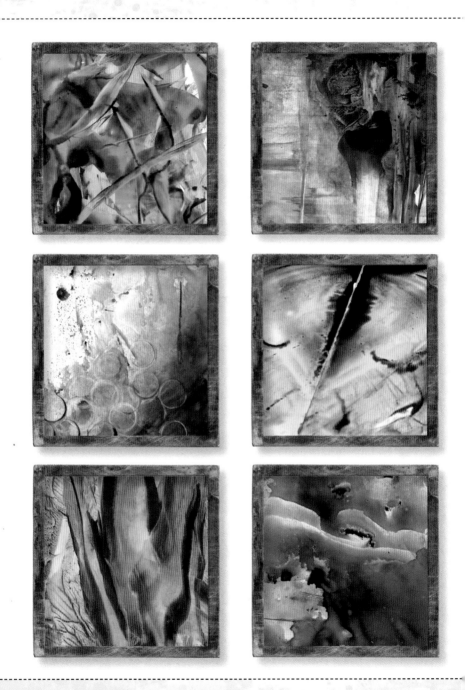

Watercolor Monotypes

with Monica Moody

The terms "monotype" and "monoprint" are often used interchangeably, but they technically refer to different techniques.

A **monotype** is a unique print made from a plate with no permanent marks. Once the image is transferred to paper, there is nothing left on the plate to re-print from.

A **monoprint** is a single impression of an image made from a re-printable plate. This plate will have some sort of permanent marks that repeat each time a print is pulled. Re-using the plate can create multiple variations and assorted colors.

If there is one thing monotypes and monoprints have in common above all, it is providing the opportunity for the artist to work spontaneously and combine techniques: drawing, painting, and printmaking are incorporated to create these distinctive works.

Materials

- Yupo® synthetic paper (74lb, 100lb, or 144lb)
- Liquid watercolors
- Acetate, glass, or other non-absorbent surfaces
- Paintbrushes, color shapers, and other tools for making marks and texture
- Water
- Freezer paper or other protective cover for your work surface
- Paper towels
- Finishing spray

NOTES:
- Each technique in this section is demonstrated on 144lb Yupo® (original) synthetic paper.
- Liquid watercolors are very concentrated. You only need a drop or two on a palette or plate. A little goes a long way, especially when adding water to the paint.

Basics

Watercolor monotypes can be done with one color and minimal supplies. The materials used in the examples below are liquid black watercolor, water, tools for making marks and adding implied texture, a small brayer, a paintbrush, and a palette knife.

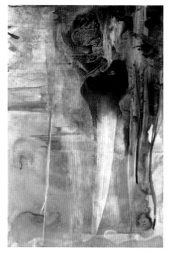

For lighter areas, use a very diluted mix of paint and water to create washes.

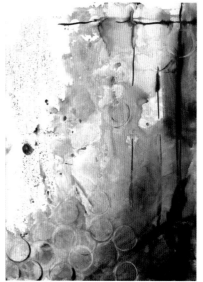

Use objects to create shapes. In this example, the lid from a small spray bottle was used to make circles.

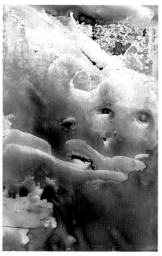

For darker areas, use a palette knife or drip paint onto the plate and allow water to move.

Tip
Spray completed monotypes with finishing spray.

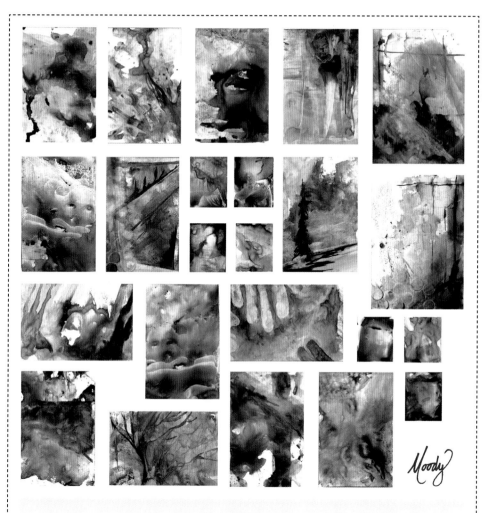

Tip

A series of abstract monotypes can be used together to create a larger piece of art. Try arranging small pieces and mounting them to a board to form an interesting montage or a cohesive collection.

Using Acetate

Traditionally, monotypes are created by drawing or painting on a glass or metal plate and transferring the image, usually after the media has dried, via hand or printing press to an absorbent surface like watercolor or printmaking paper (which is usually soaked in water before pulling the print). The use of non-porous substrates offers a modified approach for both the plate and the receiving paper. Acetate is a relatively inexpensive and easy-to-find substrate that can be used for simple monotype printmaking.

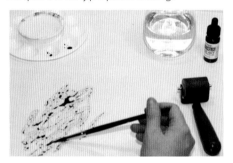

Step One Apply watercolor (and water) to the acetate.

Step Two Place Yupo® on top of the acetate plate and press gently with your hands.

Step Three Remove the Yupo by lifting up from one corner to reveal the print beneath.

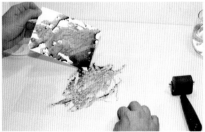

Step Four Add more paint or details as desired.

Another fun experiment: Fold the acetate while the media is still wet (or add more paint), and create a mirror image of your plate.

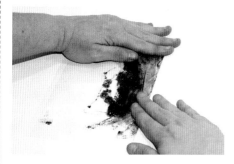

Step One Fold the acetate in half.

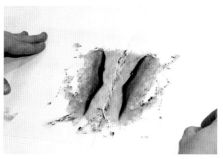

Step Two Unfold the acetate plate.

Step Three Place Yupo® on top of the mirror image and press gently.

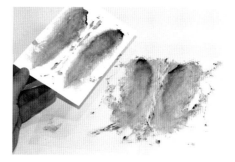

Step Four The pulled print. Add more paint or details as desired.

Tip
You may wish to re-use your acetate plate, perhaps in a mixed-media collage. Wax paper and freezer paper (shiny side up) may also be used as monotype plates and later re-purposed for use in other mixed-media pieces.

Using Yupo®

Can you use the same material as both plate and paper for printing a monotype? With Yupo synthetic paper, you can! The two projects below use synthetic paper as both the plate and the print. Add additional paint and embellishments for a more finished look.

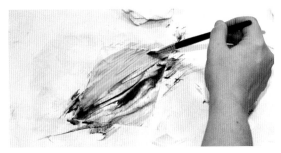

Step One Add watercolor to the Yupo plate.

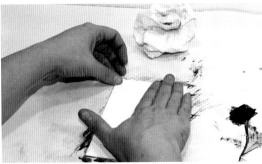

Step Two Place a clean sheet of Yupo on top of the plate and press gently.

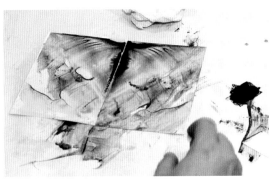

Step Three Pull the print, and add more paint or details as desired.

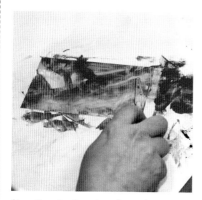

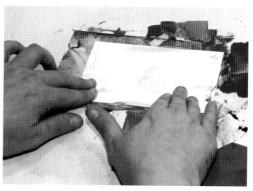

Step One Apply watercolor to the synthetic paper.

Step Two Place a clean sheet of Yupo on top of the plate and press gently.

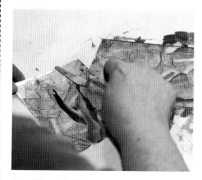

Step Three Pull the print, and add more paint with a palette knife.

Tip

Monotypes with watercolor can get messy, but don't worry; cleanup is a snap with water and a little soap.

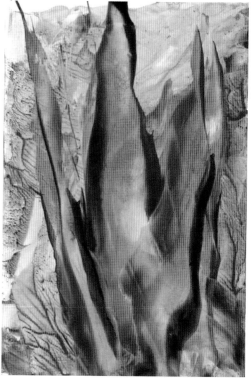

Finished piece after embellishing. (For embellishing tips, see page 92.)

Embellishing

Two of the most enjoyable aspects of creating watercolor monotypes are the spontaneity of the process and the unanticipated surprise of the results. The monotype can be further developed with embellishments, used as a background or mixed with other media to create another piece entirely. The direction you take is up to you. Experiment and have fun!

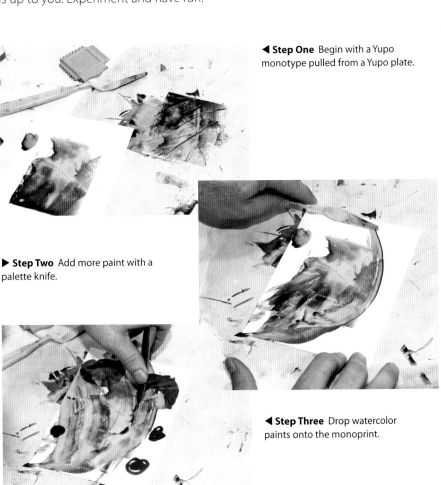

◀ **Step One** Begin with a Yupo monotype pulled from a Yupo plate.

▶ **Step Two** Add more paint with a palette knife.

◀ **Step Three** Drop watercolor paints onto the monoprint.

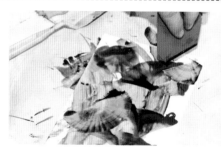

Step Four Use a shaping tool or an old plastic gift card in a circular motion to expand the watercolor drops.

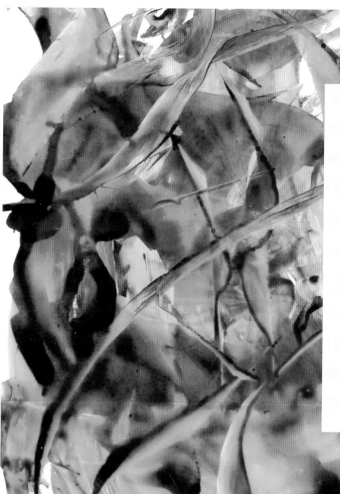

Tip

Unlike alcohol inks, which dry almost immediately on Yupo, liquid watercolors will take considerable time to dry. The more paint used, the longer the drying time. A couple of days is sufficient for a piece with light washes, but for something with more layers like the monotype above, it can take up to five or six days to dry. Once dry, I recommend spray-sealing with a finishing spray.

Pyrography

with Monica Moody

Pyrography refers to the art technique of decorating wood (or other materials) by burning on the surface with a heated metallic point. Wide ranges of pyrography tools are available, and many different types of wood can be used. The materials list will vary depending on your preferences. The following pages contain more specifics on these materials and their uses; upon review, you can better determine which materials you will need.

Materials

- Woodburning tool
- Wood
- Leather
- Sandpaper
- Small blowtorch
- Media for adding color (watercolor pencils, pan or liquid watercolors, acrylic paint, stain, wood stain markers, antiquing medium)
- Dremel® tool or drill
- Waxed thread or hemp cord for wearables (and beads if desired)
- Water
- Paper or shop towels
- Sealants or finishes for completed pieces (polyurethane, clear fixative sprays, varnish, Danish oil, or beeswax polish)

Fundamentals of Pyrography

There are many resources (books, websites, classes, and videos) devoted to pyrography, where you can find a wealth of detailed information and woodburning instructions. Here you will find a brief (but hopefully valuable) introduction to pyrography that will focus mainly on safety, an overview of available tools, and some fun ways to integrate mixed media with relatively basic pyrography techniques.

Tip
Where there's smoke, there's fire, and where there's pyrography—there's smoke!
Please take precaution to ensure you are not inhaling smoke as you burn.
A well-ventilated area is helpful, but a fan (blowing the smoke away from you) and
a respirator are recommended for your safety.

Safety

In addition to preventing smoke inhalation, you should also be aware that some woods and materials are more toxic than others. Some materials should not be burned on at all. Here are a few key tips:

- Basswood is readily available at most hobby shops and is a great wood to burn on, especially for beginners.
- Other woods that are good for beginners are birch, Italian poplar plywood, and maple.
- When burning on plywood, be careful not to burn too deep into the glue layer.
- Be mindful that burning wood may affect not only the artist but also the people around the artist.
- Never burn on: MDF; pressure-treated wood; any wood that is already stained, painted, or sealed with a finish; plastic of any kind; glues or tapes; leather that is tanned with chrome or metal; treated canvas, man-made compounds; or anything of unknown origin.

Tools

There are many brands of woodburners available, but most are one of two types:

• Inexpensive single (or variable) temperature "solid point" burners that resemble a soldering iron. These are usually found in craft stores and often come in kits with interchangeable tips or nibs.

• "Hot wire" machines, which consist of a base unit with adjustable temperature dials and separate woodburning pens that plug into the unit.

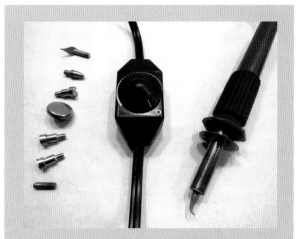

This is an example of a variable-temperature solid point burner. Tips are interchangeable, but the burner must be completely cooled before the tips are removed and replaced.

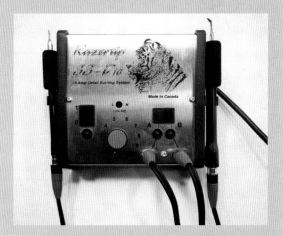

This is an example of a variable-temperature hot wire machine with interchangeable fixed-tip pens. This particular unit from Razertip® is a dual burner, which makes switching from one pen to another quick and convenient. (Pens cannot be used simultaneously.)

[PYROGRAPHY]

All projects in this section were burned with a Razertip® SS-D10 burner, using mostly skew and shader tip pens. The Razertip® dual burner has an amazing variety of fixed-tip pens. Fixed-tip simply means the tip is not removed from the pen itself, so the pens are interchangeable with the unit, instead of tips being interchangeable with pens.

The array of available pens for this type of burner can be daunting, but as pyrography expert Sue Walters notes on her website*, a beginner can do well with only three pens: a skew, a writer, and a shader.

◄ This piece was drawn with pencil and then burned with skews and shaders. The thicker lines were actually burned by turning the triangle shader pen on its side. Thinner lines, dashes and dots were made with a small skew. Some shading was done with the triangle-tipped shader pen, but many of the dark areas appear as such because of the closeness of lines that were made with a skew or the side of the shader pen. I finished this piece with two light coats of Polycrylic®.

► This deer was drawn with pencil and then burned with skews and shaders. As with the work above, turning a triangle shader on its side burned thicker lines. Small lines and marks (and all those hairs) were made with a small skew pen. The deer was burned on the exact same type of wood as the man above. The warm, rust background color was achieved by adding antiquing medium, and the dark edges of the wood were burned with a small blowtorch. (These techniques will be discussed in the following pages.) I finished this piece with two light coats of Polycrylic®.

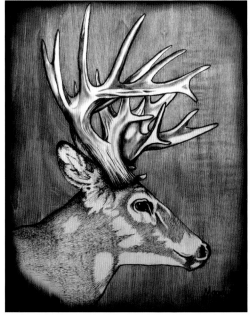

* www.suewalters.com

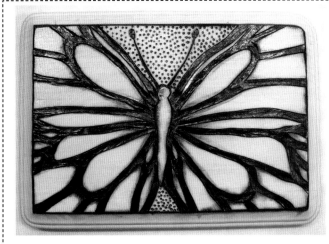

This butterfly was sketched onto the wood plaque with a pencil. Initial outlines were burned with a skew and then filled in with a triangle-tipped shader pen. The background was done with an extra-small ball-tip pen. I finished this piece with homemade beeswax polish.

Pen Types

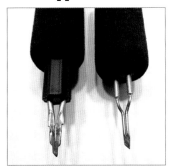

Skew tip pens

Writing tip pen

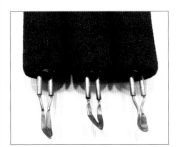

Shader tip pens

Specialty tip pens (circle stampers)

Tip

If you are not comfortable drawing freehand onto wood before burning, you can transfer a sketch or printed image by tracing it over transfer paper, or use a heat transfer tip with a woodburning tool to transfer a laser-printed image to wood. If doing the latter, you must print your subject in reverse (mirror image), especially if it includes text, so it won't be backward once transferred to the wood.

Woodburned Leather

Besides wood, there are other things you can burn with pyrography tools, such as gourds, paper, and leather. This is a quick-and-easy bookmark project that can be done with a strip of leather and a woodburning tool.

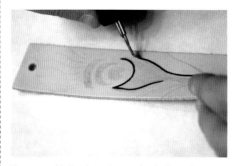

To create this bookmark, punch a hole in the top of the leather strip and sketch a peacock feather with pencil.

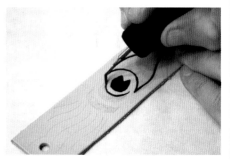

Burn the larger areas of the design first.

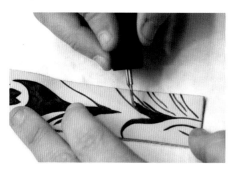

Note that when burning leather, you should use a lower temperature setting. Less heat is needed than when burning most woods.

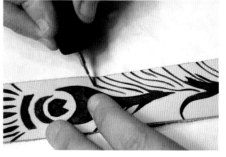

Once the main areas of the sketch are filled in, add more freehand lines.

Tip
Leather can also be colored with dyes, but in this case, I opted to keep it natural. I didn't want to chance ruining any pages with bleeding color.

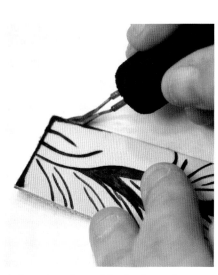

▲ Burn the edges of the leather strip to create a border.

▶ The finished bookmark (on the right), along with another bookmark that features hemp cord and beads.

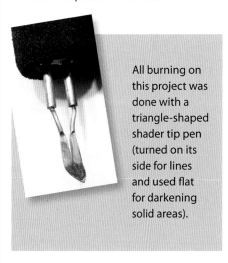

All burning on this project was done with a triangle-shaped shader tip pen (turned on its side for lines and used flat for darkening solid areas).

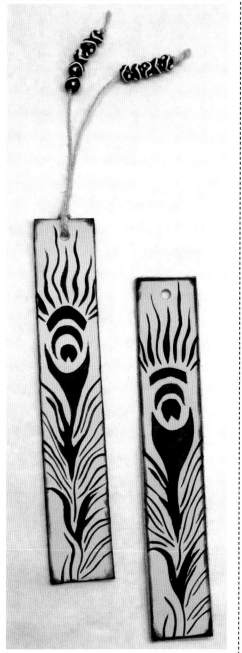

Woodburned Pieces & Color

This demonstration details a few ways to add color to woodburned art using FolkArt® antiquing medium and Inktense® pencils.

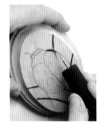
Begin by sketching a ladybug and barn owl on two wooden oval plaques. Next burn in the outlines.

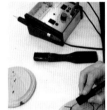
Note the black item below the burner. A tip cleaner is a little tool for removing the carbon build-up from your woodburning pen tips.

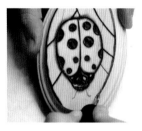
Burn a dark border on the top edges of the plaque using the triangle-shaped shader tip pen.

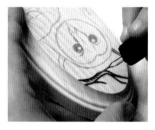
Use an extra-small skew for smaller lines and details.

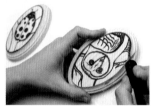
Add a little shading with a triangle-shaped shader.

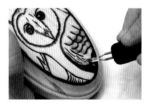

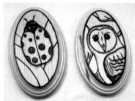

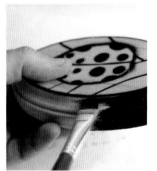

Paint FolkArt® antiquing medium around the edges, and then quickly wipe it off with a paper towel.

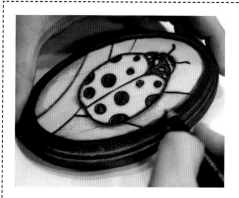

Add color with Inktense pencils.

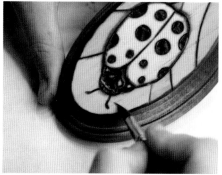

Add water with a brush to the areas colored with Inktense pencils. The color will blend and become more vibrant.

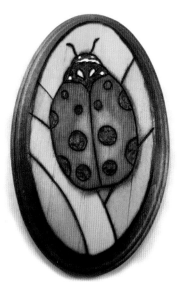

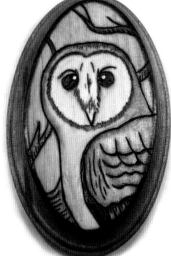

Final touches: Use a white, oil-based, fine-tipped Sharpie® to add details to the ladybug and owl faces.

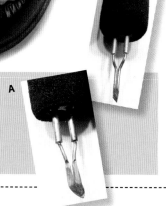

B

A

Two types of pens were used to burn these pieces: A triangle-shaped shader tip pen, turned on its side for lines and used flat for darkening solid areas (A), and an extra-small skew pen for thinner lines and details (B).

Abstracts: Go with the Grain

Burning lines along the natural patterns in wood is relatively uncomplicated and makes for a very organic, enjoyable process. For this particular project, find a plank of wood that has interesting patterns, and cut it into squares to create a polyptych (one work that is comprised of multiple panels).

Trace over the patterns in the wood with a pencil to define the areas you want sectioned off. Next burn the lines, and then color in sections with watercolor pencil, stain, and liquid watercolors. Add the bird silhouettes last to tie everything together into one scene. See the steps below for more detail on how to finish each piece.

 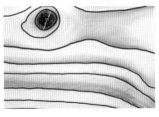

These two photos show an example of how each piece began. Natural patterns in the wood were traced over with pencil to define where lines would be burned.

Tip

Keep an extra piece of wood nearby that was cut from the same plank, to use as a tester—both for burning and coloring. You can re-purpose the tester into a piece of its own by burning further and adding more color.

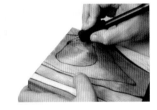 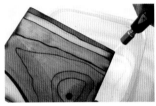

Using a tester piece, continue to burn lines along the wood's natural patterns.

Use a small blowtorch to burn the edges of the piece.

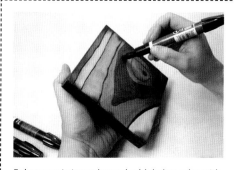

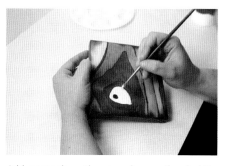

Enhance existing color and add darker color with wood stain markers.

Add more color with watercolor pencil and white with acrylic paint.

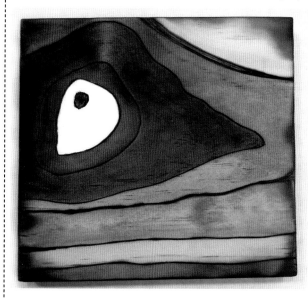

All burning on this project was done with a triangle-shaped shader tip pen (turned on its side for lines and used flat for darkening a few larger/solid areas).

Tip

Stain (painted on or from markers) may bleed if your burned lines are not deep enough to create a border between areas you wish to color separately. It's always a good idea to experiment on test wood. As a bonus, your test may ultimately become its own work of art. However, stain may also bleed unexpectedly, regardless of the depth of your woodburned marks.

[PYROGRAPHY]

Wooden Wearables

Create woodburned pendants from slices of maple. The slices of maple have a very natural look, with the bark still on the outside edges. However, you could also make these pendants from laser-cut wooden circles or other shapes available from hobby stores.

Sand each slice on both sides, and drill a hole at the top with a Dremel® tool. Sketch designs onto the slice with a pencil.

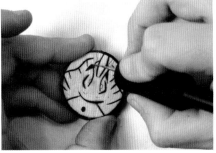

Burn thicker lines with the side of the triangle-shaped shader tip pen, and use a small skew pen to burn smaller lines and details.

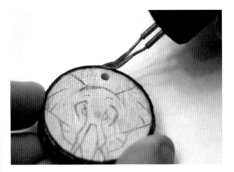

Use a triangle-shaped shader tip pen to burn a border on the bark around the top edge of the slice.

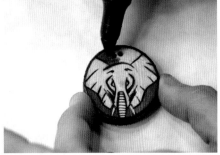

Use wood stain marker to color in the background.

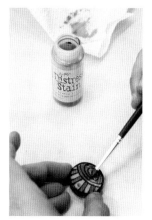

For this pendant, use a blue Tim Holtz® Distress Stain with a paintbrush.

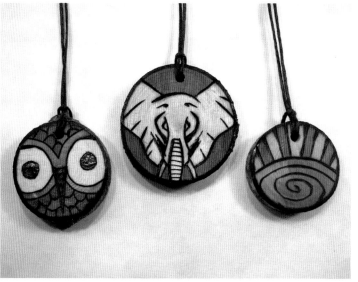

String finished pendants with waxed thread. You could also use a chain or a leather or hemp cord.

B

A

Two types of pens were used to burn these pieces: a triangle-shaped shader tip pen, turned on its side for lines and used flat for darkening solid areas (A), and an extra-small skew pen for thinner lines and details (B).

Burn Outside the Box

Pyrography is a wonderful way to create unique and eye-catching functional art. This skeleton box is the perfect project for Halloween!

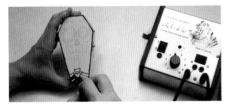

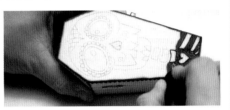

Draw a sugar skull design onto a coffin-shaped box with a pencil, and begin burning the background around the sketched design.

On the sides of the box, you can create a patterned border by pressing the edge of the triangle-shaped shader tip pen along the perimeter.

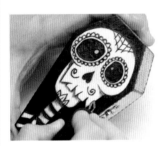

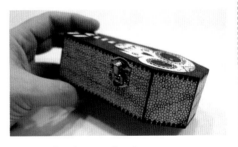

Switch to a small skew tip pen to burn in outlines and details.

Use a small circle stamp burning pen to create the patterned background around the box edges.

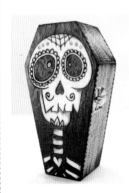

Use a small blowtorch to burn the edges along the sides of the box.

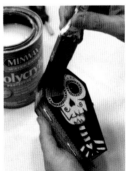

Brush on two light coats of Polycrylic® to seal the completed box.

In this example, a printed image is transferred using heat transfer on a solid point burner.

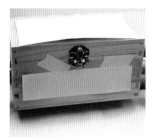

Tape the printed images to the top and front of the box. Be sure that the images are printed as mirror images.

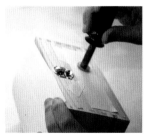

Using the solid point burner with a transfer tip, go over the back of the paper in a circular motion.

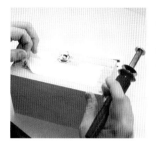

Peek behind the paper to make sure the image is transferring.

Use the transferred image as a guide to burn the image into the wood.

Add an antiquing medium to all sides and the bottom. Lastly, burn the edges with a small blowtorch.

A triangle-shaped shader tip pen (A) and an extra-small skew pen (B) were used for both pieces. For the flag box, a small circle stamper (C) was used to create the background all around the edges.

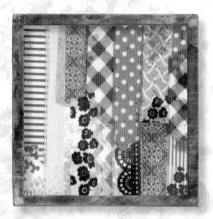

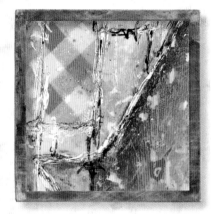

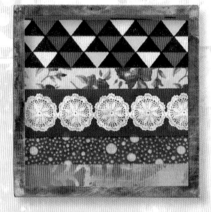

Washi Tape
with Heather Greenwood

Washi tape is a decorative tape that you can use in many ways in your mixed-media projects. It is transparent and comes in several fun patterns and solids. It's a fun way to adhere embellishments and ephemera to a surface and has a variety of other uses in design as well.

Materials

- Washi tape
- Gel or matte medium
- Acrylic paints and inks
- Mixed media paper (art journal, canvas)
- Assorted stamps and stencils
- Brushes
- Palette knives
- Brayer
- Sponges
- Scissors
- Stickers, book paper, tissue, and other ephemera or paper scraps
- Shape punches or die-cuts

Collage Background

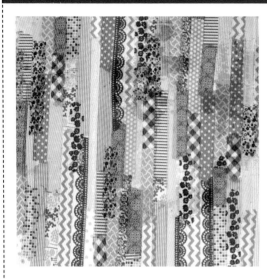

Step One Create a background using gel medium or matte medium to adhere and seal several strips of washi tape. Cover the whole page or canvas. Because the tape is transparent you will be able to see any paint or pattern below the tape. This example uses washi tape in vertical stripes, but you can mix it up in many directions.

Step Two Once you've finished filling the page with washi tape strips, you can start layering other mixed-media techniques over the top and still see patterns from the tape in the background below.

Tip

You can use a mask to protect an area from the layers of paint that will later reveal the collaged background for part of your design.

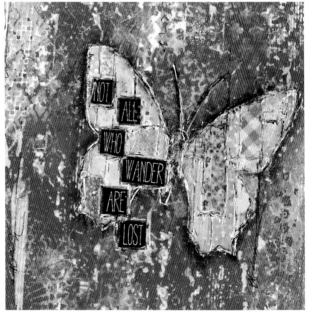

Design Element

Washi tape can be used as a single part of the design of your project as a whole. Layer strips to bring attention to where you want people to look on the page, or use the tape to ground an object so it's not floating in your design, such as the bind on the notebook below. The tape in this example gives the bird a place to rest its feet.

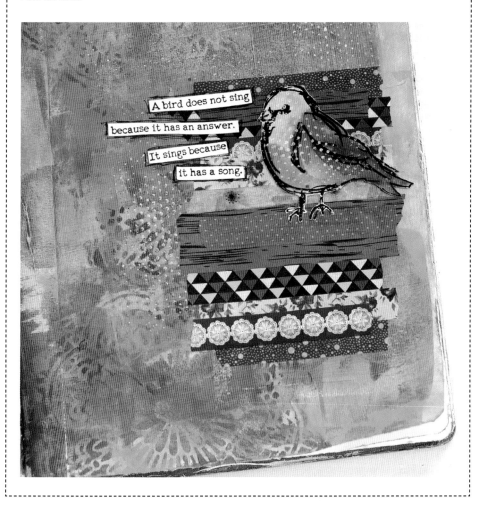

A bird does not sing because it has an answer. It sings because it has a song.

Masking

Washi tape isn't very tacky and not a permanent adhesive, so it can be lifted up and moved around when needed. This means that it can be used for masking off areas on a background to create a pattern.

Step Two Once the background is completely dry, add washi tape in a pattern.

Step One Create a background by layering assorted acrylic paints and stencils.

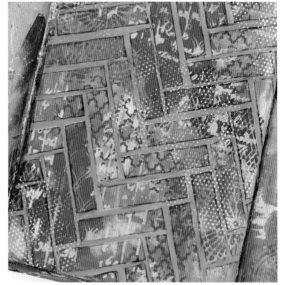

Step Three Paint over the tape, and then pull it up before it dries completely to reveal the pattern. This will prevent pulling up dried paint and will give you crisp edges. Once completely dry, add your finishing touches.

Step Four Once completely dry, add your finishing touches.

Shapes & Embellishments

Cover a piece of scrap paper with strips of washi tape. Once you've filled a page, use your scissors to cut out shapes to use as embellishments. You can also use shape punches and die-cuts to cut out the shapes. Add the embellishments to your page using gel medium to adhere it.

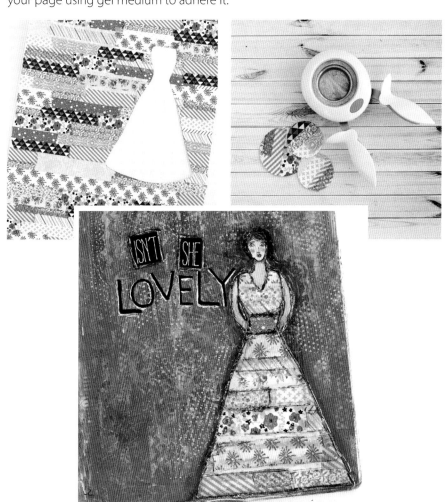

Alternative Surfaces

with Heather Greenwood

Mixed-media techniques don't need to be limited to a canvas or paper. The techniques can be used on just about any surface. Take a look around your home and you will find many alternative surfaces you can alter using mixed-media techniques.

Materials

- Acrylic paints and inks
- Gesso
- Matte medium
- Glaze
- Acrylic sealer
- Assorted stamps and stencils
- Brushes, palette knives, brayer
- Acrylic frame or album
- Fabric (burlap, raw canvas, denim, etc.)
- Clay (pre-made pieces or make your own)
- Styrofoam shapes
- Wood surface (plaque, frame, furniture, etc.)
- Stickers, book paper, tissue, and other ephemera or paper scraps

Acrylic

Acrylic is a fun transparent surface for mixed-media techniques. To keep it transparent, keep the layers thin. Here, dry brushing creates a thin layer of colors, blending them together across each piece to create an ombré effect. Dry brushing keeps the background layer thin so you can still see light shining through it. Use stamps and stencils to add more texture and design. You can add collage and doodles, layering them to create a fun semi-transparent piece.

Tip
To prevent paint from chipping, be sure to seal it with a layer of matte medium or an acrylic sealer.

Burlap or Fabric

You can add mixed-media techniques to any fabric surface. The difference between a store-bought, pre-made stretched canvas and fabric is that most often the canvas has been pre-primed. Fabric that hasn't been primed with gesso will absorb the paint. A primed surface will allow the paint to sit on top.

Use a palette knife and heavy gesso with a stencil to create a design for the background. When dry, use a heavy gesso with another stencil to create a focal point for the piece. Even after the flower is colored with paint and India ink markers, you can still see where the surface is gesso and where it is raw burlap. This creates a beautiful textured effect.

Clay

Clay is a fun and creative surface to paint. You can purchase pre-made clay shapes or create your own pieces with clay from the store.

◀ **Step One** Create your shapes and bake or air-dry them according to the directions on the package.

▼ **Step Two** Paint, stamp, or stencil designs onto the clay. Once dry, you can adhere stickers and other ephemera to your piece. In this example, the butterfly is stamped and painted on white tissue paper, which becomes clear when adhered using matte medium. Permanent pens were used to doodle around the stickers.

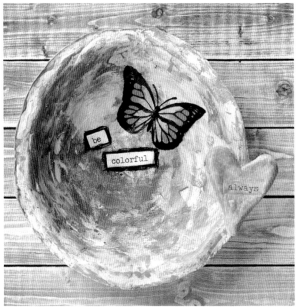

Step Three Use glossy acrylic glaze to give your piece a glossy shine, and then seal it all together with an acrylic sealer.

Glass

Glass is another fun transparent surface to work with for mixed media. For this technique, be sure to use something that you won't be eating or drinking from, as you won't be able to use it for food purposes anymore.

In this example, paint a solid background all around a glass jar. Once dry, apply stamps and stencils. Use paint markers to draw flowers. Lastly, add details to the flowers with pens. Once finished, be sure to seal it with an acrylic sealer to prevent the paint from chipping.

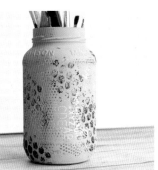

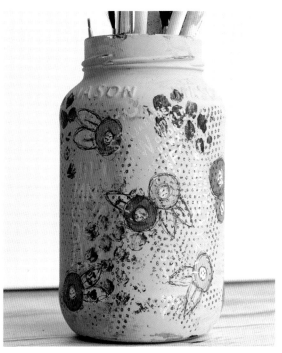

Tip
For stamps, use a brayer to add the paint before stamping a clean image on your surface.

Styrofoam

Styrofoam comes in all sorts of fun shapes and sizes. They first need to be prepped or primed prior to applying any techniques.

Step One Prep the surface.

Option One: Spread molding paste or gesso all over the surface to prime it and smooth out the Styrofoam. Use heavy gesso to give it some bumps and fun texture, much like molding paste would do.

Option Two: Use a fluid adhesive like matte medium to decoupage the surface with old book paper, lace, fabric, etc.

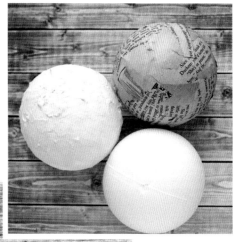

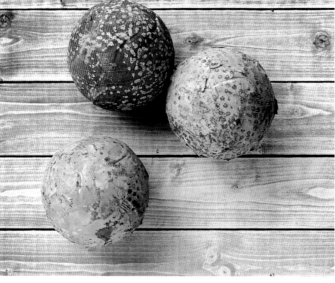

Step Two Once the gesso or decoupage is dry, add layers of mixed-media techniques such as stamps or stencils.

Wood & Muslin

Wood

Wood is an excellent surface for mixed-media techniques. You can find wood surfaces all over the place, from furniture to frames to palettes. If you want to be able to see the wood grain in your finished product, be sure to keep the paint thin. Dry brushing is really great for this.

After dry brushing the background, add paint to the background using stamps and stencils. Using a brayer on your stamps will keep the paint thin and give you a clean stamped image. Once you have a background, you can add collage pieces, stickers, or ephemera to finish it.

Tip

If you get too much paint in an area, grab a baby wipe while the paint is still wet and wipe off the excess, or even spread the paint around with the baby wipe. If the paint has dried and you want to remove more, use rubbing alcohol and a cloth to wipe away more paint.

Muslin

You can use many mixed-media techniques on many types of fabric. One way to make a gift personal is to paint, stamp, and doodle on a muslin bag.

Wordsworth because he knew that he was destroying his native poetry by the smugness of his life, but neither theory explains why this feeling about children arose when it did and became so general. There is much of it in Vaughan? after the Civil War, but as a general tendency it appeared when the eighteenth-century settlement had come to seem narrow and inescapable; one might connect it with the end of duelling, also when the scientific sort of truth had been generally accepted as the main and real one. It strengthened as the aristocracy became more puritan. It depends on a feeling, whatever may have caused that in its turn, that no way of building up character, no intellectual system, can bring out all that is inherent in the human spirit, and therefore that there is more in the child than any man has been able to keep. (The child is a microcosm like Donne's world, and Alice too is a stoic.) This runs through all Victorian and Romantic literature; the world of the adult made it hard to be an artist, and they kept a sort of tap-root going down to their experience as children. Artists like Wordsworth and Coleridge, who accepted this fact and used it, naturally come to seem the most interesting and in a way the most sincere writers of the period. Their idea of the child, that it is in the right relation to Nature, not dividing what should be unified, that its intuitive judgment contains what poetry and philosophy must spend their time labouring to recover, was accepted by Dodgson and a main part of his feeling. He quotes Wordsworth on this point in the Easter Greeting'—the child feels its life in every limb; Dodgson advises it, with an infelicitous memory of the original poem, to give

Spray Ink
with Heather Greenwood

There are many different kinds of spray ink. Most of them are water-soluble and will reconstitute when they get wet. There are also some that are permanent when dry. You can also make your own spray inks by adding water or airbrush medium to acrylic paints. The benefit of the permanent spray ink is that it doesn't reconstitute when it gets wet. However, if you use water-soluble spray ink, you can seal it an acrylic sealer before adding other wet mediums on top.

Materials

- Mists
- Spray inks
- High-flow acrylic paint
- Spray bottle
- Paper (art journal, book paper, paper scraps)
- Gel medium
- Acrylic sealer
- Assorted stamps and stencils
- Brushes
- Palette knives

Misting & Reverse Misting

Step One A good start for a background is to mist over a stencil. To get a nice mist rather than a puddle, hold the bottle several inches above the stencil and move your arm across as you spray.

Step Two Once you have finished misting over the top, lift the stencil.

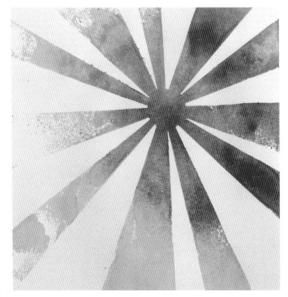

Step Three Press the excess mist on the stencil down on another piece of paper, like a stamp. This will give you a reverse misted impression.

Dipping & Tinting

Dipping

For a marbling effect, try dipping paper into puddles of spray ink.

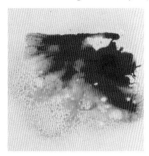

Step One Spray ink onto a craft mat or palette paper. Move the colors around to blend them, but don't completely mix them into one color.

Step Two Dip your paper into the puddle of spray ink and let dry.

Step Three You can dip the paper a few times (drying in between each dip) to create fun patterns.

Tinting

Make spray inks permanent by mixing them with gel medium or gesso.

 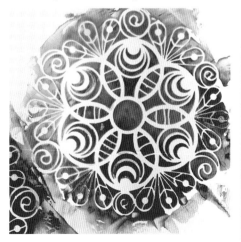

Put a dab of gel medium on your palette, spray the gel with ink, and then mix it together. This is a great technique for adding details through a stencil. Tinting gel medium with spray ink keeps it a vibrant color, and gesso gives the gel a more muted or pastel color.

Stencil Resist

Using spray inks on an absorbent surface like paper will give you a different look than it will on a surface like gesso or gel medium. Gel medium will resist the ink and can easily be wiped away.

Step One Using a palette knife, add gel medium through a stencil and let dry.

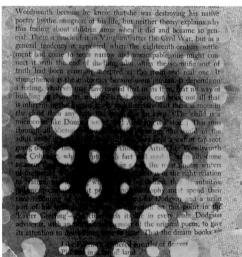

Step Two Once dry, spray ink over your paper and wipe away the excess to reveal the stencil resist.

Stamping & Painting

Stamping

Using spray inks is a great way to get a watercolor look with stamps. This technique works really well with foam or rubber stamps that cover a large surface area.

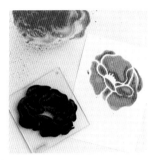

Spray some ink on your palette, dip your stamp into it, and stamp it down on your paper.

Painting

Spray inks are similar to watercolor. You can dip paintbrushes into the ink to paint backgrounds, script words, stems for flowers, etc. For bigger brushes that don't fit in the spray bottle, you can spray the ink directly onto your palette.

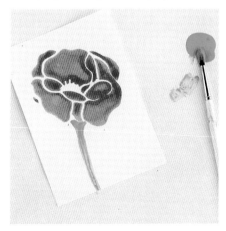
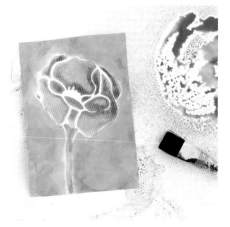

Ephemera

with Heather Greenwood

What is *ephemera*? According to *Merriam-Webster,* ephemera are things that are important or useful for only a short time or items that were not meant to have lasting value. This includes paper items (such as posters, broadsides, and tickets) that were originally meant to be discarded after use but have since become collectibles. There are so many things that can be considered ephemera in addition to paper items, such as vintage beads, buttons, game pieces, and jewelry. The important thing to realize about ephemera is that it can be anything you want it to be and that it is a great addition to any piece of mixed-media artwork.

Materials

- Assorted ephemera (paper items, old books, magazines, sewing patterns, buttons, playing cards)
- Gesso
- Acrylic paints (assorted colors)
- Brushes
- Palette knives
- Adhesive (gel medium, matte medium, glue stick)
- Jewelry-making supplies (facets, bails, beads, findings)
- Diamond glaze resin or epoxy
- Doodle pen
- Scissors
- Stencils (optional)
- Hole punch
- Binder rings

3-D Flowers

There are so many things you can do with 3-D ephemera flowers! Paint, cut, and layer them with other ephemera to add to your projects.

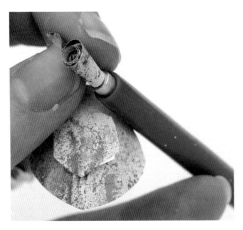

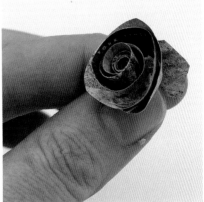

Step One Cut the paper into a circle, and then start cutting a spiral to the center. Use a pencil, a small rod, a skewer, or tweezers to roll the paper from the outside edge inward, keeping the bottom edge aligned until you get to the center.

Step Two Remove your pencil or rod and let your flower naturally unwind. Glue the center to the bottom of your rolled flower, and fold out the top edges.

Tip
Add rolled flowers to the centers of cut-out flowers (A). Paint and doodle, and add ribbon or buttons to the center of your 3-D flowers for a vintage look (B).

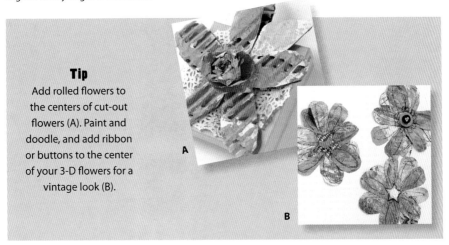

A

B

Torn Collage Background

This technique is very similar to collage, but instead of completely gluing ephemera to the background, it is torn away at random.

Step One Using a palette knife, spread gel medium or matte over the background randomly, but don't cover the whole background. Adhere paper ephemera to the areas where you added glue and let dry.

Step Two Once dry, begin to tear away the loose ephemera, leaving the parts that are glued down. Fill in areas with other mixed-media techniques, and repeat the first three steps to layer and build up your background.

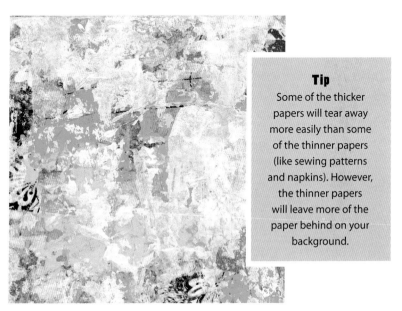

Tip
Some of the thicker papers will tear away more easily than some of the thinner papers (like sewing patterns and napkins). However, the thinner papers will leave more of the paper behind on your background.

Jewelry

Stamped Pendant

Step One Paint or stamp patterns on a road map, and then cut out a piece to use as the background behind a facet.

Step Two Glue the piece to the facet using diamond glaze resin. Add a layer of resin to the back to encase the paper and protect it. Finish the piece with wiring and vintage beads.

Woven Necklace

Use ink to stamp or paint designs and colors onto ribbon and lace, and weave them into a necklace. Use vintage buttons as beads when creating your mixed media jewelry.

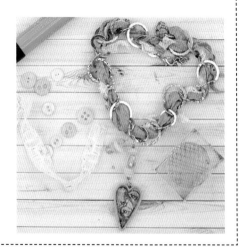

Albums & Keepsakes

Ephemera is a great effect for decorating keepsakes, such as mini albums and inspirational flip books. Use quotes from favorite books or shapes from old greeting cards to personalize scrapbooks and journals, or create a travel album with ticket stubs and other memorabilia to document special memories. The possibilities are endless!

Step One Create a flip book from a set of old playing cards! First, add a layer of gesso on one or both sides. Then add your favorite mixed-media techniques.

Step Two Add more ephemera, or stamp on inspirational words or quotes. To finish, punch a hole in the corners and add a binder ring to keep them together.

Tip
Go through your old magazines and junk mail in the recycle bin to find unexpected items, such as fun quotes and unique fonts, to use as ephemera. Paint, cut, and layer them together with other memorable items to add a finishing touch to your projects.

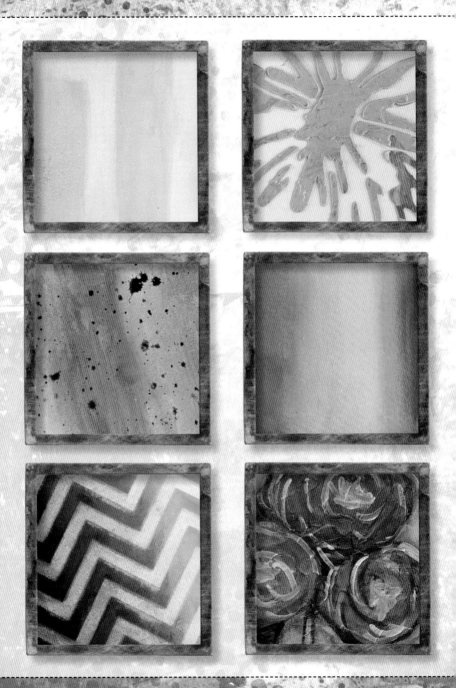

Gelatos®

with Heather Greenwood

Gelatos® are water-soluble pigment sticks that are acid free and perfect for paper crafting and mixed-media projects. They have a creamy consistency similar to lipstick and work very similarly to watercolors. They can be used for a variety of techniques, such as stenciling, stamping, and creating complex and colorful backgrounds.

Materials

- Faber-Castell Design Memory Craft Gelatos®
- Mixed-media paper
- Canvas
- Water brush or paintbrushes
- Baby wipes
- Gel medium, gesso, modeling paste (any other mediums for coloring)
- Stencils
- Palette
- Palette knife
- Acrylic sealer or fixative
- Spray bottle filled with water

Painting

Using paintbrushes with water, you can pick up some pigment from the Gelato stick and use it just like watercolor paint. If the colors are still wet on the surface, they will blend nicely together. If they are dry, you can add layers of color that won't blend together.

> ### Tip
> Painting on an absorbent surface like paper will help the paint dry faster. Gelatos become permanent once dry.

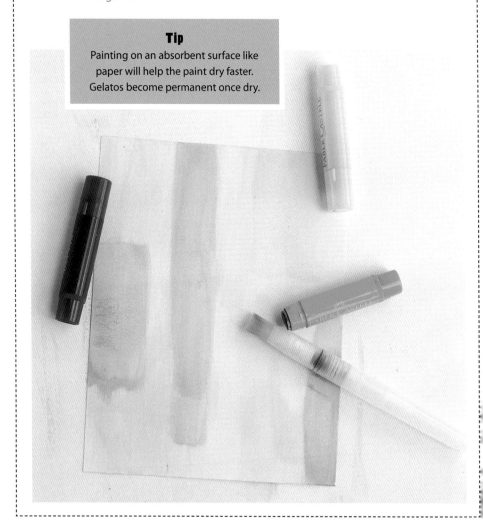

Blending

For more vibrant color, use the Gelatos to draw directly on the surface like a crayon. Use your fingers or a blending tool to rub it in and blend the colors together. This works best on a primed surface that won't absorb the pigment.

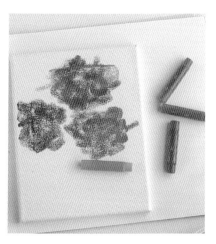
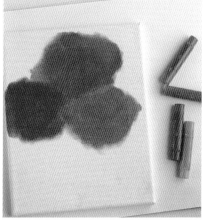

Tip
As it takes place on a primed surface, this method takes much longer to dry. To add more wet mediums over the Gelato, you must first seal your work with an acrylic sealer or fixative. For this piece, clear matte gel medium was spread over the top so that additional techniques could be added.

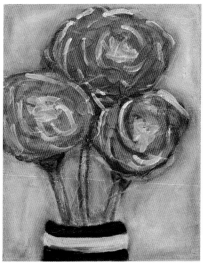

Mixing with Mediums

Mixing Gelatos into gel medium will keep the color vibrant and give it a thicker consistency that is perfect for stenciling. You can also mix them into gesso or modeling paste for a more pastel or muted color.

Step One
Using a palette knife, cut off a little bit of the Gelato and smash it up until smooth.

Step Two Mix in your chosen medium.

Step Three Spread it over a stencil or canvas. If you use a stencil, be sure to remove it and wash quickly so that the mediums don't dry on your stencil.

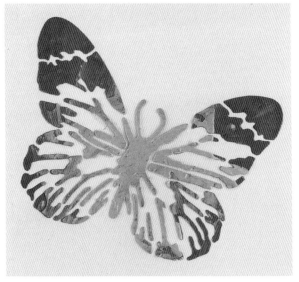

Drips & Splatters

This technique is best used on a nonabsorbent, primed surface. You can do it on an absorbent surface such as paper, but it will flow better over a primed surface.

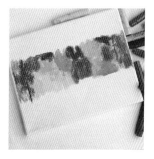 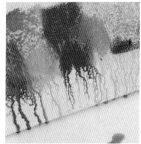

Step One Color the surface and blend the Gelatos.

Step Two Using a spray bottle; spray with water to activate the Gelatos. Let the colors blend a little more.

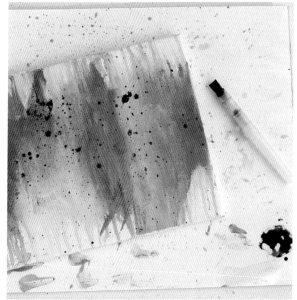

Tip
For splatters, rub some Gelatos onto your palette and add water to get it wet. Use a wet brush to flick the splatters onto the surface.

Step Three Turn your surface on its side and spray again. To get the drips to flow more, tap it down a few times. If the Gelatos get clumpy, use your finger to smooth it out and let drip some more.

Stenciling

Adding Color

Because Gelatos are a solid, it makes them easy to use with stencils for a watercolor effect.

Step One
Rub the Gelato stick over the stencil in the areas you want the color.

Step Two
Use a baby wipe to activate the color, and rub it in to fill the stencil area.

Removing Color

This technique is very similar to the stenciling technique above, only instead of adding color with baby wipes, we'll be wiping it away.

Step One
Color your background with Gelatos, and then blend to activate their color.

Step Two
Holding the stencil over the top, start wiping away the color. Use new wipes for each color to avoid mixing.

Tip

This technique works best with a nonabsorbent gesso-primed surface. Use a sealant or fixative if you plan on adding other wet mediums over the top.

Stamping

This technique works best with foam or rubber stamps but will work with some clear stamps too. Using this technique, you can blend several colors together to get the exact color you want rather than looking for the perfect inkpad. It can also be used to add shadows and highlights to stamps by coloring some parts darker and some parts lighter. An absorbent surface like paper works best for this.

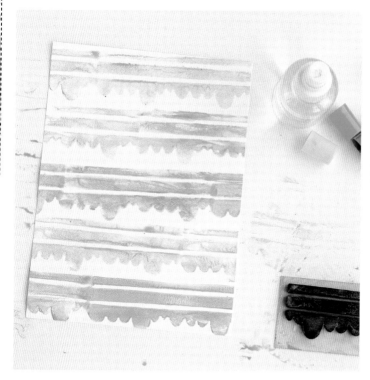

Step One Color the stamp with Gelatos.

Step Two Spritz the stamp with water a few times, and let it sit to activate the color and blend.

Step Three Stamp down on your surface.

About the Artists

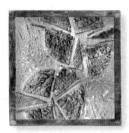

Cherril Doty is an artist and writer in Laguna Beach, California. While she holds a masters degree in counseling psychology, the need to create called, and Cherril followed her muse to try new art forms and possibilities. Mixed media represents the culmination of the search and is the process by which she achieves still more through teaching and experimentation. Visit *www.cherrildoty.com* to learn more.

Heather Greenwood is a self-taught mixed-media artist who loves to be creative in everything she does. She is known for adding mixed-media flair to her memory-keeping scrapbook albums, planners, DIY projects, and art journals. She teaches and inspires projects and techniques on her blog, *www. heathergreenwooddesigns.com.*

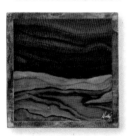

Monica Moody is an artist from Dallas, Texas. Known for her vibrant alcohol ink paintings, Monica also enjoys mixed media, illustration, relief printmaking, pyrography, and watercolor painting. Visit *www. monicamoody.com* to learn more.

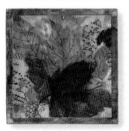

Marsh Scott is a multi-media artist from Dana Point, California. Embracing media of all kinds and in all sizes, from jewelry to large public art installations, Marsh especially loves to create art rich with texture, layers, and color. Visit *www.marshscott.com* to learn more.